Camera at Sea

CAMERA AT SEA

A Professional Approach to Marine Photography

Jonathan Eastland

ASHFORD, BUCHAN & ENRIGHT
Southampton

Published by Ashford, Buchan & Enright,
an imprint of Martins Publishers Ltd,
1 Church Road, Shedfield, Southampton SO3 2HW

British Library Cataloguing in Publication Data

Eastland, Jonathan
Camera at sea.
1. Marine photography
I. Title
778.9'37

ISBN 1 85253 212 2

Typeset in 11 on 13½pt Sabon by
Words & Spaces, Portsmouth
Printed in Great Britain by Staples Printers, Rochester
Bound by Hartnolls Ltd, Bodmin

CONTENTS

BLACK AND WHITE PHOTOGRAPHS

COLOUR PHOTOGRAPHS

Between pages 56 and 57

For my father, Raymond Lee Eastland

INTRODUCTION

The sea provides a continuing and stimulating challenge for photographers. In general terms, there is such a wealth and variety of subject material that no one photographer could exhaust its possibilities in a dedicated lifetime of work. The novice, the serious amateur and the professional photographer could find widely differing facets of the subject to which years of work might only scratch the surface. The sea itself is a fascinating subject, changing from second to second, minute to minute and hour to hour of each day; constantly changing light, the changing moods of the sky, the ebb and flow of tides all affect our perception of how the sea looks. It is singly the most difficult aspect of this subject to photograph well. Since Gustave le Gray first exhibited his albumen seascape prints in the Paris Salon in 1850, photographers everywhere have strived to capture the essence of the sea.

The sea is also a gateway to hundreds of other subjects which can provide day to day fodder for hungry photographers; boats and ships of all shapes and sizes, yacht and powerboat racing, people and personalities, the sailors and yachtsmen and women whose lives are devoted to living and working in that environment. The romance of a 'tall ship', at sea or in harbour; these majestic vessels provide a never-ending source of material for the imaginative photographer. Commercial shipping provides a wealth of material to the more architecturally inclined. Great liners of the world demand to be photographed in the grand manner in order to capture their huge scale. The powerful tug boat, the sleek frigate and slinky submarine all need a different interpretation. Estuaries and the ever-changing coastline are dotted with creeks and harbours that hide an extravaganza of photographic material.

Recently, I spent a few days searching England's West Country for wrecks of old sailing ships which had been left to die quietly in some muddy corner of a farmer's creek. Here were fascinating time capsules of marine history accessible to any photographer willing to pull on a pair of rubber boots. Wrecks such as these are scattered far and wide around the coastlines of the world. This treasure chest is added to almost daily by the dozens of modern ship founderings, the locations of which can be sourced from a single international marine newspaper, *Lloyd's List*.

Some photographers specialise in the relatively tight-knit and comparatively small world of international yacht racing. Its apparent glamour and pacey lifestyle draws photographers from all parts of the world to the great events which may be sailed in locations as far apart as Cowes or Perth, the China Sea or the Baltic. International yacht racing offers a wide variety of weather conditions, and the opportunity to experience a panorama of sailing which cannot be had from one venue alone. Some of these may appear to be exotic, tropical, the stuff of dreams. Very often they are; but just as often they are not. I have spent as much time shivering under the inclement weather of far-off places as I have enjoying the summer sunshine of my home patch. The mistrals and meltemis of the Mediterranean can be as unpleasant as a North Sea gale.

For the professional, there are times when coverage of a particular event can mean travelling half way or even all the way around the world in search of pictures. This has advantages and disadvantages, the latter usually being far outweighed by the excitement and sense of adventure which foreign assignments can stimulate. But there is no guarantee that the pictures you come home with will be any better or in more demand than something you could have taken on the home stamping ground. For the freelancer, there is the financial consideration: the expense of travelling far and wide is colossal in terms of the likely return; the effort required simply to cover one's expenses and the time it will take for the funds from published work to accumulate in the bank are major considerations the photographer cannot ignore.

In recent years, the number of professional marine photographers has increased dramatically from a handful of twenty years ago to more than a hundred today. In addition, there are many more amateur photographers worldwide who have turned to the sea for their camera subjects. In this book, I have been concerned primarily with two aspects of photography – the image and the tools with which to make it.

The American photography writer Howard Chapnick observed in 1982, 'The grand delusion of contemporary photo-journalism is that anyone can make great pictures.' Given the equipment that is available off the shelf today this delusion is perhaps more sustainable. Equipment need not be the very best that money can buy, but it should be substantially engineered and of an ergonomic and aesthetic design which appeals to the photographer. Bear in mind also that the environment you are about to enter takes more than its normal toll on photographic equipment; some items mentioned in the book have been found to give a good performance over many years of hard work; others are new and have yet to stand the test of time.

The ability to recognise picture possibilities as they develop before the camera is also important. This is a combination of inherent talent and what some photographers call 'instinct' – the experience and knowledge gained from years of practice, of constantly searching the horizon for the unusual angle, of learning how to use lenses as tools to obtain a specific image rather than simply as optics to magnify. 'Instinct' is knowing what will happen when a ship begins to pitch and roll in a heavy sea, knowing whether the design of a particular yacht will help it to surf over the waves in a squall or sink further into its own hole. It is being able to recognise when a yacht is about to broach out of control or when a powerboat is about to leap off the top of a wave and attempt to become something it was never intended to be.

The dedicated marine photographer, armed with a basic knowledge of seamanship and yacht-racing rules, will have an advantage over the photographer who lacks that knowledge. This book introduces the new-comer to some of the basics such as how certain hull shapes perform and how these shapes can be interpreted photographically. A section on elementary weather observation is designed to encourage the concerned photographer to learn more about this fascinating and useful subject.

In the early days of my career I learned more about what makes a good picture from studying the work of others; in books, magazines, newspapers, advertising brochures and movies. It's a habit I've never lost and one which should be encouraged amongst all who are concerned to produce meaningful imagery. The idea is not to copy another photographer's style but to learn from great works what is possible and how that might be achieved. Good photographers are also thinkers who invariably take the trouble to plan pictures. The elements which can make a great picture possible may be in the photographer's mind for many years before they finally come together in a cohesive manner to make an outstanding work. At other times, instinct can pull the elements together to make a great picture in a split second when the basic elements of a good blow and superb light combine to give the photographer all he or she could wish for in a morning's work.

My personal feelings about the photographic possibilities the sea has to offer change each time I walk along the shore or head out through the mouth of the river to open water, and capturing the very essence of what it is all about frequently has me baffled. It is that more than anything which perpetuates the challenge of photographic discovery.

Jonathan Eastland
Hamble River, 1990

3

1. (OPPOSITE) *Canberra departs. From the whole of a 35 mm frame, shot with a 180 mm lens. A square format negative would have required cropping to achieve the same effect.*

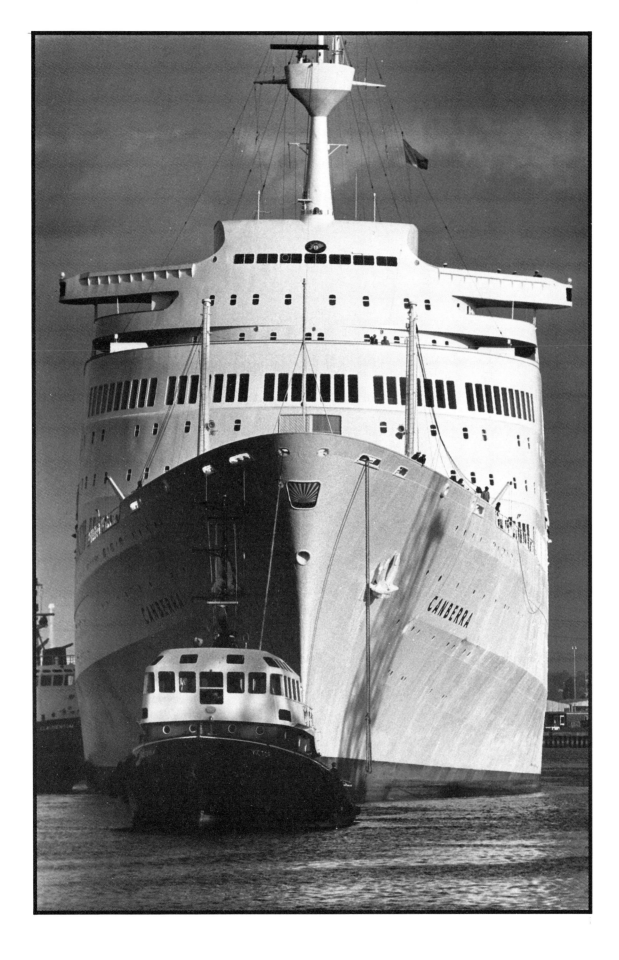

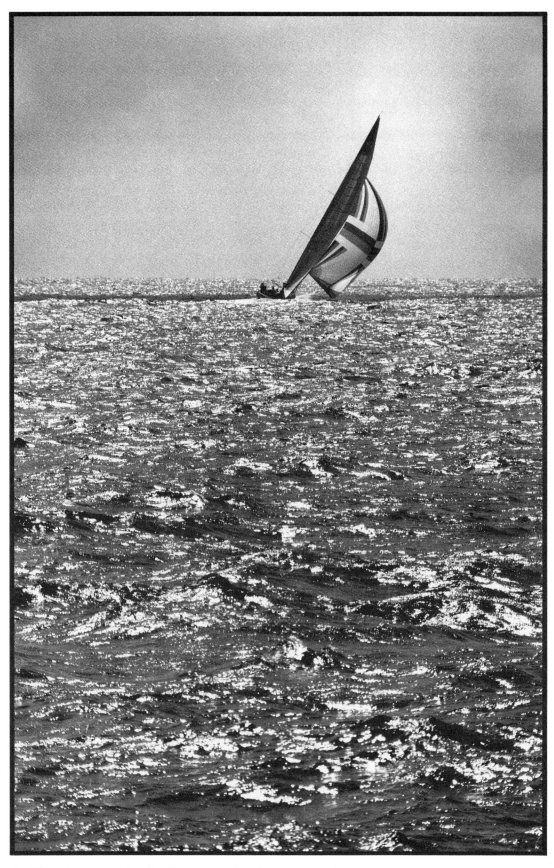

2. *Glistening sea: a polarising filter was used to sharpen spectral reflections off the water.*

1

CHOOSING EQUIPMENT

Why, you might ask, have I chosen to devote the first two chapters of this book to the hardware side of the business? With the range of sophisticated cameras and accessories increasing each year there are many factors which should influence the photographer's choice of hardware, particularly the choice of lenses. What is good and what can be consigned to the rubbish bin is invariably handed down by word of mouth or by camera-journal reviewers who have tested, investigated and evaluated the many different products on offer. However, investing in the most expensive hardware is not always a guarantee that the product will produce the result required. Even the best factories can occasionally produce a duff lens that slips through the quality-control checks. When selecting equipment, perhaps the best approach is to find a dealer who is prepared to supply equipment on loan for a few hours (or more) so that you can give a practical film test for optical performance and get a feel for the hardware. Handling the product is likely to provide more information than either the salesperson or the manufacturer's advertising. For instance, the Pentax campaign of the early 1960s, which invited the potential buyer to 'just hold a Pentax', was certainly the reason for the great success of that product.

Once you have settled on a particular 'system', you can build from a basic kit of parts into a really useful armoury by adding, from time to time, the lenses and accessories you think you will need. Obviously, if you are a first-time buyer, consider what the market place is offering with a great deal of care. Rushing out and buying the latest heap of space-age, gimmick-laden hardware could just be the start of a monumental nightmare. For instance, some camera manufacturers have been known to produce an excellent piece of hardware which then captures a terrific following. Then, suddenly, without any warning, a new model from the same maker hits the headlines and you find that all the lenses you purchased for the earlier model do not work on the new one. The best guide is 1) if in doubt, leave it out, and 2) follow the benchmarks set by professionals who have already tried, tested and adopted certain makes over long periods of time.

For those investing anew in equipment, the first consideration is likely to be format since this, above all else, determines the way in which the photographer perceives the subject.

FIRST AND FORMAT

Photography is such a personal means of expression that there can be no hard-and-fast rules about what the format for any given subject should be. In my case, I was weaned on the large and medium formats. I didn't own a 35 mm instrument for some years and my relationship with the format has been a little erratic, going through a variety of periods where it began life as an accessory, became the mainstay of my work for over a decade and has now become one of a set of different tools. From a purely commercial point of view, the square format has produced a far higher number of 'best selling' pictures than the small 35 mm format.

Larger Formats

Despite the increased use of 35 mm SLRs for 'yachting' photography, there are photographers who use larger formats either exclusively, or in conjunction with the smaller format.

Larger formats have their own pros and cons. A 5 × 4 in transparency – the see-through postcard – is difficult to beat when it comes to impressing picture editors, but using a 5 × 4 in camera requires considerable dedication. Handling is slow; it cannot be easily packed in a gadget bag and produced willy-nilly to bang off a couple of shots; lenses are expensive and are comparatively limited in focal-length range. It is not economical in use and most types available, with the exception of the Toyo Speed Graphic, are cumbersome instruments requiring a tripod for best results. Even worse, in the maritime environment, the 5 × 4 in camera is difficult to proof against the elements.

Notwithstanding these drawbacks, the overriding advantage of a 5 × 4 is that, in the right hands, it can produce work of outstanding quality. Richard Kraus, for instance, who is noted for his landscape work, has spent several years recording the coastline of Britain with just such a camera.

A more manageable, larger-than-miniature format is 6 × 6 cm. Cameras employing this square format produce a useful negative size which allows a variety of cropping techniques to be employed by the darkroom photographer as well as the publisher. Various camera types are available, all using the popular 120 or 220 roll film.

Nearly all subject matter can be approached in a different way, depending on the tool being used. Before choosing a suitable format, photographic purpose must first be established. I would instinctively use the smaller format to shoot a scene of unfolding drama; not because I don't think it could be portrayed in a similar way with a larger format but more because the intimacy of the 35 mm instrument and the shape of its format inspires a

certain type of image. There are practical considerations too, particularly at sea. It is not easy, even in experienced hands, to hold a medium- or large-format camera fitted with a long lens steady against a bucking platform. If another tool can accomplish the job with ease, why not use it?

Occasions do arise when certain pictures present themselves and simply demand to be recorded on a format of specific shape. Once, when covering the naming of a super new cruise liner at which royalty was present, the obvious picture of the occasion appeared to be an overall view which took in the ship, the podium on which Her Royal Highness was standing, the band, the colourful streamers and hundreds of spectators. I took the picture using an ultra-wide-angle lens and was totally unimpressed by what I had recorded. Shortly after the champagne bottle had smashed against the side of the ship, the crew raised a cheer for Her Royal Highness and someone let off a string of balloons. I had just picked up the 6 × 6 cm camera, intending to shoot a couple of general crowd scenes, when it became apparent that the balloons, cheering sailors and part of the ship would make a far better picture of the occasion. It is possible that, had I not had the larger format with me, I could have made a similar picture with 35 mm; at the time, however, it was the fact that I already had the medium-format camera to hand that inspired my interpretation of the scene.

Conversely, I doubt I would have seen the picture of the SS *Canberra* leaving harbour in the same way had I been using a medium-format camera. The overall shape and subject content was perfectly framed in my 180 mm lens on a 35 mm reflex. A square or larger negative would have required considerable cropping in the darkroom to achieve the same effect.

The reader may reasonably deduce from these notes that the larger format is inclined to encourage a looser approach to composition; the smaller format, a much tighter approach. This may be so. On the other hand, it is not necessarily an attitude I would support or encourage. What should be understood is that all formats can be used in any way the photographer is inclined, but the physical shape and size of a format is likely to influence interpretation and perception of the subject, often without the photographer realising it. If that is the case, then there is an element of truth in the oft-quoted adage that it is not the camera but the person behind it which is the key to successful photography.

FORMAT AND LENS QUALITY

Small-format lenses are generally designed to have greater resolving powers than lenses designed for larger formats because small-format nega-

tives undergo significantly greater magnification than their medium- or larger-format counterparts to produce similar-sized prints. For instance, the 4×5 in negative needs to be magnified only twice to make a standard 10×8 in print, whereas the 35 mm negative requires at least $8 \times$ magnification to produce a print of equal size. For this reason, and contrary to a misleading piece of photographic legend which would have us believe otherwise, larger-format lenses do not, generally, give sharper definition than small-format types; using them with adapters on smaller-format cameras is therefore unlikely to produce sharper results.

In a clean and disciplined dark room, it is possible to obtain prints of the highest quality from 35 mm negatives that are certainly equal and often superior to those produced from larger formats by commercial laboratories. However, I must also admit that I have found it easier to produce shoddy work from the small format than from the larger format; and giant enlargements from *larger* negatives will retain their overall apparently sharp quality way beyond the stage at which the smaller-format negative image has disintegrated and become nothing but clumps of grain. Furthermore, in practice, the sharpness of photographs taken in the field (as opposed to specific tasks conducted with definite limitations) is invariably viewed subjectively. Light, selective focus, camera shake, flare, contrast, edge acutance, subjective movement and texture are all contributory factors to the viewer's assessment of print sharpness.

MTF Tests

Not so very long ago reviewers of cameras and lenses made their assessments of lens quality by running film through the camera and producing a set of enlarged prints from various segments of the best negative: centre, edge, top, bottom and so on. From this, the reviewer was able to make fairly accurate comparable judgements concerning lens performance. Nowadays, MTF (modulation transfer function) tests employ optical and electronic methods of testing a lens without using a camera or film. Through this advanced and much simplified method of appraisal distribution agents and reviewing magazines are able to group together lenses of certain focal lengths and price according to the average MTF figures. The problem, in my view, is that the lens manufacturer often assumes that its potential buyer knows as much as they do about MTF. The explanation given below may be useful to readers who are not familiar with this testing system.

An electronic collimator measures image contrast at 'x' cycles per millimetre resolution of one sample ('x' being a nominal figure equal to the finest detail discernable by the human eye for a given print size held at

normal viewing distance). The results of an MTF test can be expressed in terms of a percentage figure where the maximum is 100, or in terms of lines per mm, where the range covered is 0–100.

The system can only be viewed as a very rough guide to the quality of a lens, since in practical field tests there are many other variables to be taken into consideration, quite apart from manufacturing errors which creep into the system from time to time. The final arbiter of whether a lens is any good or not will be its ability to produce a crisp and well-defined image under a variety of lighting and exposure conditions.

Film

A further consideration in deciding on format relates to the resolving capability of film. Panchromatic emulsions for general purpose photography are capable of resolving between 50 and 200 lines per millimetre. Films with a thinner emulsion base and slower ISO rating have a higher minimum figure, between 150 and 200 lines per millimetre. Compared with glass plates of decades past, modern film is sharper and capable of higher resolution on a format-for-format basis. However, excellent quality can only be achieved with the small format by meticulous attention to every stage of the negative- and print-making process. Obviously, it is much easier to attain that same quality with medium format. From even larger negatives, say 5×4 in, using no special techniques, overall quality is usually excellent.

MANUAL OR AUTOMATIC?

Apart from any personal preference that I may have for the ubiquitous cog and brass rod, reliability is my main concern. I am not convinced that the all-pervading chip is as reliable as the public at large have been given to understand, even in ordinary environments. In a marine environment, electronic instruments have a far higher failure rate due to the ingress of moisture which causes irreparable damage. Mechanical cameras can invariably be repaired and if they are serviced frequently, will last considerably longer than the electronic version, of which there is a high turnover in units returned for fault repairs in the first 'guarantee' year of consumer ownership.

For the photographer investing hard-earned cash into a system that it is hoped will last a lengthy period, this must be a serious consideration. The only way to change the view apparently held by manufacturers that the user is the field tester for new products is to write to the relevant head office, complaining loudly. The precedent set by Leica, who, after discon-

tinuing the M4 rangefinder some years ago, were bombarded with requests to restart production, is encouraging. They did indeed do so and it is as a direct result of that independent move by aficionados that present production includes the magnificent Leica M6.

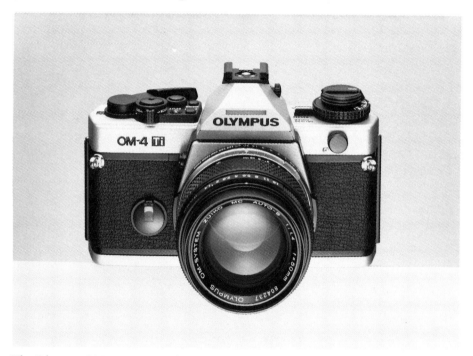

The Olympus OM4Ti system reflex camera offers lightness, superb build quality, one of the most accurate light metering systems known and a superb range of lenses.

Autofocus

At the time of writing the new wave of auto-focus point-and-shoot compact SLR and hybrid 'comflex' cameras seem to be accounting for the highest sales figures worldwide but serious hobbyists also appear to be as concerned as ever that the user has total control over the instrument. With some auto-focus models it is possible to utilise manual-focus lenses; with others it seems totally unnecessary.

Since most auto-focus cameras use a system of infra-red beams which detect a difference in subject contrast to obtain sharp focus, there are bound to be instances when the system fails at the critical moment. At sea, the light playing on the moving subject constantly alters and, as a result, the contrast of small areas of the subject continually changes also. Since only a small area of the lens is used to detect these changes, unavoidable movement of the photographer and the subject can prove to be problematic.

Some auto-focus lenses can be focused manually, usually by sliding forward the auto-focus mechanism cover to reveal a fairly narrow rubberised ring. Sometimes, on shorter focal-length lenses, the manual-focus ring is at the very end of the lens, a place which is hardly suitable for accurate focus as it upsets the operating balance of the equipment.

While discussing auto-focusing, it is worth mentioning two smaller 'compact' cameras which have this facility as their main feature, and which are suitable for the marine environment. The first model is the splashproof and weatherproof Olympus AF–1 which is easily pocketable and very quick to use. A high quality 35 mm lens gives a sensible angle of view. It is ideal for use on board a boat as a point-and-shoot camera and will produce enlargements of quite remarkable quality. The other is the Nikon LWAF, a completely waterproof (to 3 m) camera which is fitted with an excellent 35 mm f/2.8 lens. It is somewhat bulkier than the Olympus but produces superb results, nonetheless. As it is sealed by a heavy-duty gasket around the opening back and its lens is protected by an outer optical glass filter, it is the kind of camera that the imaginative photographer might find useful at any time.

Autofocus or hocus pocus? Sophisticated and technologically advanced systems like the Canon EOS range offer ergonomic styling which can easily be semi-waterproofed with 3M tape.

13

Other 'compacts' with manual-focus devices similar to the Nikon LWAF are also available: the Fuji HDM is one. If usage of the waterproof type is likely to be, at best, intermittent and in relatively shallow water or near-surface conditions, this type of camera is a relatively inexpensive investment. A more sophisticated type with interchangeable lenses comes in the form of the Nikonos V, designed as a dedicated submariner's 35 mm camera. It is especially useful for underwater work when employed with shorter focal-length lenses.

CHOOSING LENSES

Camera-name or independent lens?

Camera-name lenses for the professional market (lenses that are designed and produced by the camera maker as opposed to an independent lens manufacturer) are of a very high optical and mechanical quality and it is therefore worth paying the extra for these lenses as a guarantee of reliability, overall quality and consistency of image tone. However, when the lens you want is not made by your camera manufacturer, or it far exceeds the budget you had in mind, it is worth considering buying a lens from an independent manufacturer. Japanese companies, such as Sigma and Tamron, are now producing more moderately priced versions of some of the more exotic high-performance optics. These companies also cater for the non-professional market, aiming cheap products at a wide variety of camera users by the simple method of standardising lens design so that only the rear mount is varied on production lines. In Sigma's case, the lens is supplied with a fixed mount; in Tamron's, their 'adaptall' mount is purchased independently. The latter's argument in favour of this method is that a photographer changing systems need only change the lens mount, thus reducing the financial investment. The argument against this has always been that the removable rear mount is a weak link in the system chain which can, and does, cause problems.

A further important consideration when choosing a lens is the likely knocks to which it may be subjected. The hobbyist is likely to adopt a more concerned approach toward the care of equipment. It is not that professionals are generally negligent with regard to equipment; in an assignment situation, the only concern is to shoot the picture. During the actual process of shooting, many things may be happening around the photographer to which he or she is completely oblivious. I have frequently looked on as photographers and their equipment are thrown unceremoniously from one side of a boat to the other, then pick themselves up

14

only to be thrown back from whence they came. In these circumstances, even the toughest piece of equipment becomes vulnerable to knocks and bangs: cameras develop hair-line body cracks; expensive lens mounts shatter; electronics get swamped; printed circuit boards fuse into a useless mass; photographers go swimming when they never intended to. But these are occupational hazards which the professional marine specialist is prepared to take every time he goes afloat.

Independent lens manufacturers are continually improving their products; optical quality is generally very good and in the case of more expensive lenses of the wide-aperture, long focal-length variety, overall construction and lens quality is excellent, offering a viable alternative and additional choice of focal lengths in a variety of ergonomic designs which differ from the camera-brand array.

Telephoto Lenses

As with many specialist subjects, there is often a requirement for special lenses. In sports photography long telephoto lenses – those with wide apertures in the region of f/2 to f/4.5 – enable the photographer to get closer to the action. At yachting events, the camera man or woman is frequently placed in a position where long lenses are essential to record the action. Anything from 300 mm to 600 mm is not unusual.

The reason for using exotic telephoto lenses centres around their flexibility. By adding a 1.4 or 2× converter to the lens, focal length can be dramatically increased without serious loss of lens speed or optical quality. At events like the America's Cup, where photo launches may well be restricted to a minimum distance of 500 m, and the average is 750–1000 m, the photographer is seriously disadvantaged, not just by the position but by having to resort to equipment which requires considerable skill to handle well. Large-aperture lenses are heavy; if sea conditions are even moderately rough, the chances of missing the moment, or worse, making a bodge of it, are increased dramatically.

It is only in the last few years that these 'dinner plate' lenses have been available. The advent of internal focus has improved their handling qualities enormously and this mechanism is gradually being introduced to other manually operated lenses. But is the large aperture an essential piece of equipment in a marine environment? My experience over the years has proved beyond any reasonable doubt that whatever the person standing next to me can do with an f/0.995 × 1200 mm lens, I can do with a lens of far less exotic specification. Furthermore, the simpler the equipment, the less cumbersome it is likely to be. Imagine the situation: two of us are standing on the after-deck of a fairly large and spacious motor cruiser. We

15

are five miles offshore and the sea state is moderate – lots of big swell, but not too rough. Our 50-foot chariot rolls happily, gunwale down one side to gunwale down the other. Occasionally, there is a hefty jolt as we slam into a big sea which sends green water and sheets of spray cascading over the wheelhouse to land on the after-deck, soaking anyone who hasn't the presence of mind to react swiftly enough and duck for cover under the large awning. The photographer standing next to me is wielding a huge beast of a lens, a 600 mm f/4.5 on to which a 2× converter is fitted, giving an effective focal length of 1200 mm. He cannot support the weight of this monster for long and simultaneously bring the camera viewfinder to eye level without the additional support of a monopod which is fitted to the lens with a ball-and-socket head. The other end of the pod is slotted into a sport fisherman's rod support which the photographer has strapped around his waist. In this way, he is now able to perform a kind of marine photographer's ballet around the after-deck, occasionally attempting to bring the camera and lens to eye level when the subject appears on the horizon. A high-speed motor rattles off 20 frames in a few seconds as the lens draws a graceful arc through the sky, the boat rolls once more and the photographer performs a few subtle steps to catch his balance.

I didn't make this up. I have seen it happen several times and have listened to the sad tales at the end of the day when the processed film revealed its secrets. Neither are these circumstances rare. You don't have to go to an America's Cup event to see the circus. In fact, I have never been to an America's Cup event where the conditions under which photographers shoot have been anything like as bad as in the English Solent. A little wind over tide in this region can fairly set the heart racing as one proceeds to sea to watch the start of a race. I have experienced many occasions in the Solent when trying to shoot pictures from a moving platform with anything much longer than a 300 mm telephoto has been a nightmare. And it is under these conditions that certain types of lenses have proved indispensable.

A German lens called the Novoflex employs a unique pistol grip focusing device for its telephoto lenses. The concept was originally devised for use in wildlife photography and, before the advent of fast-aperture telephoto lenses, was widely accepted as one of the most practically useful pieces of equipment in the sports photographer's kit. Novoflex now make a fast-aperture 300 mm lens which employs the pistol grip device linked to an internal focus mechanism. The optics are produced by Tamron and its specification is approximately the same as for Tamron's own f/2.8 300 mm LDIF lens.

The earlier Novoflex lenses of the 400 mm variety are true telephoto lenses employing doublet or triplet lenses with a maximum aperture of

f/5.6. This piece of equipment is effectively one long aluminium tube into which is inserted a manually adjusted iris. The lens can easily be converted to a longer 600 mm focal length by removing the 400 mm lens head and inserting an extra length of tube to which the new lens head is attached; the maximum aperture now becomes f/9. Compared with the modern apochromatic or low-dispersion glass element lenses, the lens speed of the Novoflex at 600 mm is painfully slow and can cause serious problems if a shutter speed faster than $\frac{1}{250}$ second is required when using slow ISO film. Even so, under the right lighting conditions, the near-perfect balance and comparative lightness of a 400 mm or 600 mm arrangement can, to some extent make up for the lack of lens speed. Novoflex is constantly improving its long lenses and, at the same time, it is possible for well-used ones to be reground, polished and recoated with surprisingly effective results.

With either lens, it is possible to shoot perfectly sharp pictures at very slow shutter speeds without the use of a tripod, monopod or other support. I have used one of these lenses for many years; although I own others of the faster variety, I still prefer to use the Novoflex out on the water or when working from a helicopter, mainly because I am used to its peculiar characteristics. The Novoflex may have given me cuts and bruises but it has always risen to the occasion. There are some pictures reproduced here that I am sure I would have missed or messed up with a heavier, more imbalanced piece of equipment. In particular, the picture which won the 'Kodachrome Cup' in 1987 is worth a little discussion.

On another America's Cup race day, I had been flying around the course off Fremantle with my pilot Dave McKay, looking for unusual angles on the two boats 1000 ft below. To obtain a compacted view of the boats, the helicopter had to be positioned either a long way behind or a long way in front of the yachts, and slightly off to one side of their course. Our particular helicopter could not be flown sideways without some difficulty, so that eliminated a frontal position that could be held long enough for me to frame up and rattle off three or four frames.

Another problem was that height restrictions within a 600 ft lateral radius of the yachts were dramatically increased. Outside that limit we could fly at 500 ft. But it was still too high and too distant. By flying at high speed in a circuit around the yachts while climbing to 1000 ft (the height restriction inside the 600 ft circuit) and then diving upwind across their sterns and pulling out into another climb, it was just possible to squeeze two yachts together with a 600 mm lens. In fact the 'g' force on the camera lens made it possible to aim and steady the lens at just the right moment. A few trial runs were made with some reasonable success, but

that day lacked the bright and breezy weather that would have the boats ploughing along in a surf.

On another day it was blowing so hard that we were surprised racing had not been called off. It was a day of blow-outs and men overboard, the kind of conditions that are made for dramatic racing pictures. Sitting on the floor of the helicopter with my feet dangling below, I used the Novoflex chest pod and my wellington boots to grip the lens. By tilting my head slightly, the camera viewfinder fitted snugly into my eye socket and all I had to do was coax Dave through the flight sequence we had tried a few days before and concentrate on focus to get the picture I wanted. The exhilaration of such an occasion is difficult to describe. There is a lot of noise; through the headphones there is a great deal of shouting to and fro as the crucial moment gets closer. The pilot is yelling that he can't go lower, the helicopter is at maximum speed and vibrating like hell. Unsuppressed engine noise practically overwhelms sensible conversation. You scream back 'Just a few more feet . . . don't stop now . . . keep going, keep going!'. Over the top of the phones, there is the whirling cacophony of rotor blades and the rush of wind past the open door. You feel as though you are about to be sucked out into a nightmare as the 'g' force changes from one direction to another; all the time concentrating on what is happening 1000 . . . 750 . . . 500 ft below.

When it's all over and you are safely back on terra firma, you still cannot be sure that what you shot was what you wanted. But there is some elation at the thought of a possible 'maybe'. Photographers usually know when they have a picture, just as surely as they know when they miss it.

Another photographer might have used a different type of lens, something heavier perhaps and faster. Leica make a peculiar 400 mm telephoto which is focused by sliding the front element tube over the main barrel by depressing a lock button on the side of the lens grip. It's a slow lens and probably just as quirky to use as the Novoflex, but it is very sharp and has an avid following among Leica users. The only real disadvantage with lenses of this type, apart from their optically snail-like ability, is that they are rather unwieldy to carry about. Nikon have among their armoury two excellent telephoto lenses, both with internal focus, but of standard aperture; the 300 mm f/4.5 IFED and the 400 mm f/5.6 IFED. These lenses can easily be carried around in a gadget bag, taking up less room than some older helical focus lenses.

Apochromatic Lens Chart

	Focal length (mm)	Max f-stop	Weight (g)	Construction groups/elements
Leitz				
Apo Macro Elmarit R	100	2.8	840	6/8
Apo Telyt R	180	3.4	750	4/7
Apo Telyt R	280	2.8	2750	7/8
Apo Extender R	1.4x	–	220	4/5
Minolta				
AF Apo	200	2.8	795	8/7
AF Apo	300	2.8	2480	11/9
MD Apo Tele	400	5.6	1490	6/7
MD Apo Tele	600	6.3	2400	8/9
AF Apo	600	4.0	5500	10/9
AF Apo Converter	1.4x	–	200	4/5
Olympus				
Zuiko	180	2.8	700	5/5
Zuiko (IF)	180	2.0	1900	8/10
Zuiko (IF)	250	2.0	3900	9/12
Zuiko	300	4.5	1020	4/6
Zuiko (IF)	350	2.8	3900	7/9
Zuiko	600	6.5	2800	4/6
Sigma				
AF Apo (zoom)	70–210	3.5–4.5	730	9/12
MF Apo (zoom)	70–210	3.5–4.5	680	9/12
MF Apo (zoom)	100–500	5.6–8.0	2480	9/13
MF Apo (zoom)	350–1200	11.0	11,000	11/17
MF Apo (IF)*	300	2.8	1980	12/9
MF Apo (IF)*	400	5.6	1100	11/7
MF Apo (IF)*	500	4.5	3000	10/8
Tamron				
SP–LD	80–200	2.8	1218	12/16
SP–LD (IF)	180	2.5	800	7/10
SP–LD (IF)	300	2.8	2096	7/10
Novoflex/Tamron	300	2.8	–	7/10

(special follow focus lens manufactured in West Germany by Novoflex with Tamron optics)

	Focal length (mm)	Max f-stop	Weight (g)	Construction groups/elements
SP–LD (IF)	400	4.0	2320	7/10
SP	200–500	5.6	2780	10/14
SP–Converter	1.4x	–	–	3/5
Tokina				
AT–X (zoom)	80–100	2.8	1080	17/11
AT–X (zoom)	100–300	4.0	1220	16/12
AT–X (zoom)	150–500	5.6	2230	15/13
AT–X (IF)	300	2.8	2140	8/7
SZ–X*	70–210	4.0	445	12/8
Novoflex				
T–Noflexar	400/3	5.6	2350	3
Angenieux				
Angenieux (zoom)	70–210	3.5	780	11/15

* Available in auto-focus versions
(IF) Internal focus device

19

Wide-angle Lenses

Wide-angle lenses, because of their small size, are far less susceptible to the knocks and bangs which larger and heavier telephotos always seem to suffer. On a performance level, there is not much to choose between any of the leading brands in the medium wide-angle range of 28 mm and 35 mm. Nearly all brands use similar six- or seven-element construction, sophisticated multicoating of all or some of the elements to aid light transmission and reduce flare, and those of the common f/2.8 maximum-aperture variety come at a reasonable price.

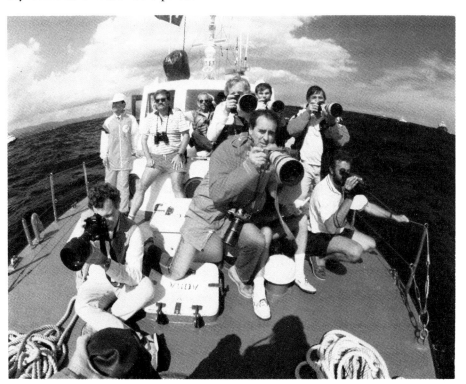

Extreme fish-eye wide angles bend vertical and horizontal planes. They are often used to create gimmicky pictures – love 'em or hate 'em!

The differences begin to be seen when faster lenses of this type are used. F/2 and f/1.4 lenses invariably show significant improvements in edge-to-edge sharpness, resolution and overall contrast and, if print quality is the ultimate aim, these faster types are well worth the extra investment. The choice of which focal length is the most useful depends largely on the photographer's purpose, but if you cannot afford both, the wider lens is likely to be more useful. If you plan to go afloat often an even wider lens will probably be a first choice. Space on yachts and small boats is always

at a premium, so the angle of view of a 24 mm lens at 84° will prove invaluable. Nearly all of the major manufacturers make an f/2 version of this optic; its close focusing ability and terrific depth of field when stopped down to between f/8 and f/11 is essential for capturing onboard, crew-at-work shots.

Wider-angled lenses can also prove useful from time to time. I have 20 mm and 17 mm lenses which I find ideal for shooting the type of interior picture widely used for advertising and brochure production. These are flat-field lenses that, if used correctly, give an expansive view without the edge distortion commonly associated with extreme wide angles. They have other uses too. If it is impossible, for various reasons, to work from a larger sea-going platform, or the event warrants the use of a smaller boat, extreme wide-angle lenses permit a much more intimate contact with the subject. How close you get to a 70-foot yacht thundering along at 14 knots with all its canvas set, depends wholly on the skill of your boat helmsman, but that aside for a moment, and assuming that anything is possible, the wider lens can produce exciting results.

Close proximity to the subject and confined space is not the only occasion when an extreme wide-angle might come in useful. On one occasion when I was asked by Olympus Optical in London to cover the departure of their namesake submarine from the Pool of London, the picture options were fairly open. My platform was a fairly large and slow-moving tugboat. The key to whether the picture I had in mind would succeed or not was the juxtaposition of Tower Bridge and the submarine. I could have shot this from a long way back with a long telephoto lens; the manoeuvring ability of my platform, however, meant that I would only have, at best, one opportunity for the picture I wanted. By persuading the skipper of the tug to follow close on the heels of HMS *Olympus*, there was a chance of several good shots as the ship passed under the raised bridge. I used a 20 mm lens, but, even so, the submarine was almost too quick for the tug and only the tug's skipper's dedication in sticking to the sub like glue saved the day. The use of a 24 mm or 28 mm lens would not, in my opinion, have given the right scale or perspective and would have diminished the visual impact of the final picture used in *The Times* the next day.

The photographer should exercise considerable care when using extreme wide-angles in the sort of situation just described. Although full-frame flat-field lenses tend not to distort horizontal or vertical planes, there are full-frame fish-eye types that do. Some people like the effect they create; personally, I loathe it, especially when the lens is misused in order to try and create an imaginative picture that could have been better executed with a lens of longer focal length.

Again, several independent lens makers have produced extreme wide-angle optics and some of these are very good value for money – if you can still find them! In particular, the Tamron 17 mm SP with integral filters is a chunky, full-frame lens with a 107° angle of view. Its maximum f/3.5 aperture is a trifle slow in confined interior situations but its overall sharpness more than makes up for the loss. Sigma, Tokina and Vivitar all make similar lenses of comparable optical quality in the medium-price bracket.

Zoom Lenses

When zoom lenses first appeared in profusion in the 1960s only the most expensive camera-brand versions gained general acceptance from the professional press photographer. The prevailing attitude seemed to be that if it didn't cost an arm and a leg, it could not have been much use, and it is fairly true to say that most of those early 'vari-focus' optics produced results that were far from satisfactory; comparisons with the kind of quality one might obtain from shooting through a dirty milk bottle were not far from the mark.

A great deal of research has gone into zoom lens design over the last two decades. The photographer is now faced with a veritable minefield of different lens types and a variety of focal-length combinations. All photographers, if they use zoom lenses at all, have their favourites. But if you have not yet developed a preference or have regarded the optical performance of zooms with some scepticism, consider the most likely purpose to which it will be put.

The most commonly used prime lens focal lengths are in the 35 mm to 200 mm range. Of these, the longer focal lengths in the region of 65 mm to 180 mm are more popular. Current zoom technology is aimed at the amateur who uses all of these lengths. The 28 mm to 210 mm zoom is produced by nearly every independent lens manufacturer but only Nikon of the major camera producers make a 35 mm to 200 mm lens. Much more common are the zooms in the 50 mm, 75 mm or 80 mm to 200 mm or 210 mm ranges; the more expensive versions invariably give better optical performance. Those at the cheaper end of the market will give corresponding results.

Overloading with equipment can create problems. Keep in mind the nature of the subject: a lot of walking and humping around the coast, along river banks and estuaries is pretty much par for the course of a dedicated marine photographer! Too much gear in a gadget bag will simply wear you out before some locations have been reached.

If you are uncertain about which of two formats to begin with but cannot afford both, the smaller one will be less financially painful and can

provide all the versatility the beginner is likely to need. Starting off with the greater restrictions which the larger format imposes, however, may teach you more in the short term about how to make a 'picture'. Always remember that your camera, however highly prized, is a tool; provided it can accomplish the tasks set for it with ease and a degree of finesse, the only honest reason for change has to be because another, newer, different tool can do the job better.

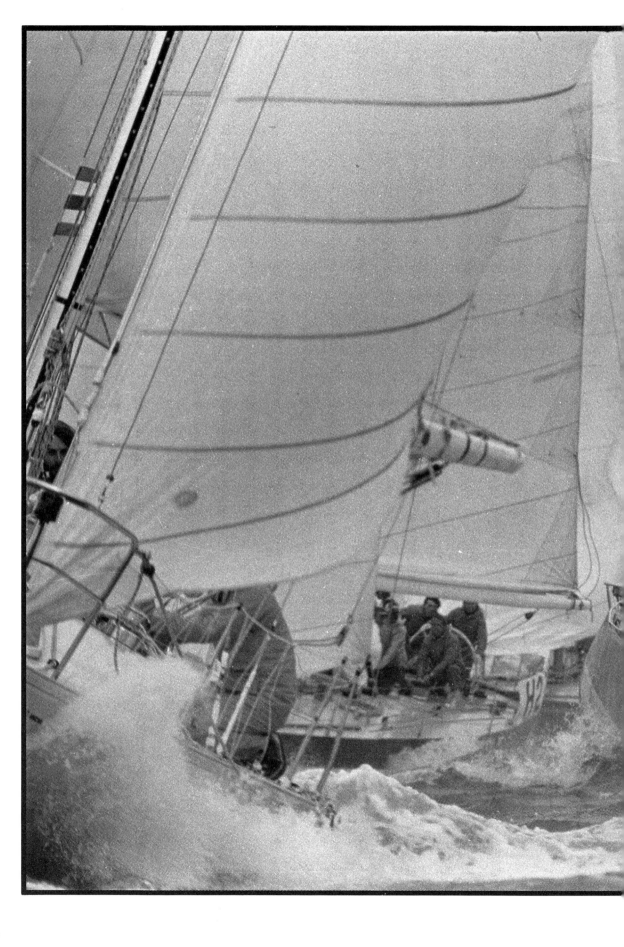

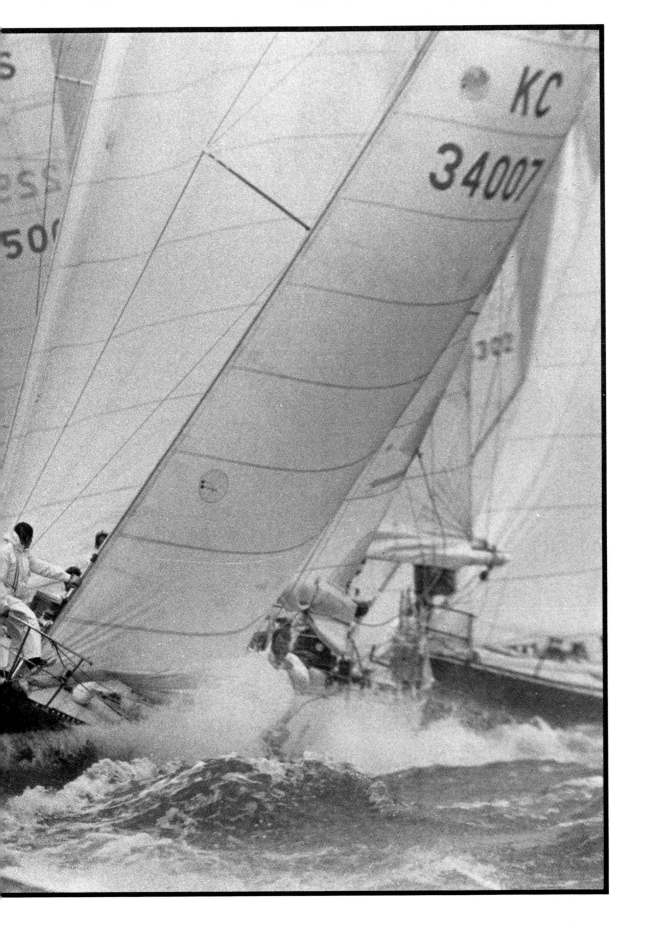

4. *Working in the marine environment can become a test of endurance for the specialist photographer, so keep gadget bags light. Access to this wreck of the* Amsterdam *required a hike across suspect sands and mud.*

3. (PREVIOUS PAGE) *Admiral's Cup start – only time for a few frames, and only one that worked. Novoflex 400 mm Follow-Focus lens.*

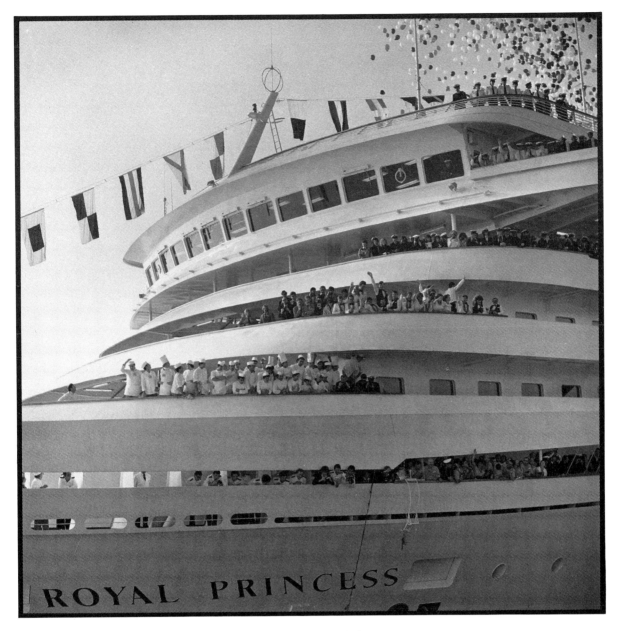

5. *Naming ceremony: the square format ideally suited the tiered elements of the picture.*

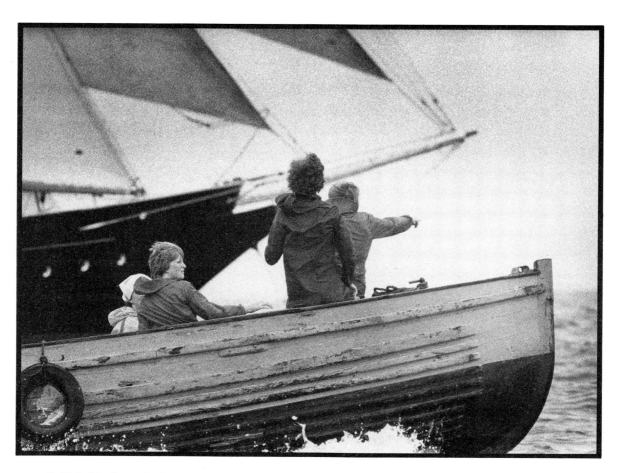

6. *Tall ships leave the Fowey. 35 mm SLR, 105 mm lens.*

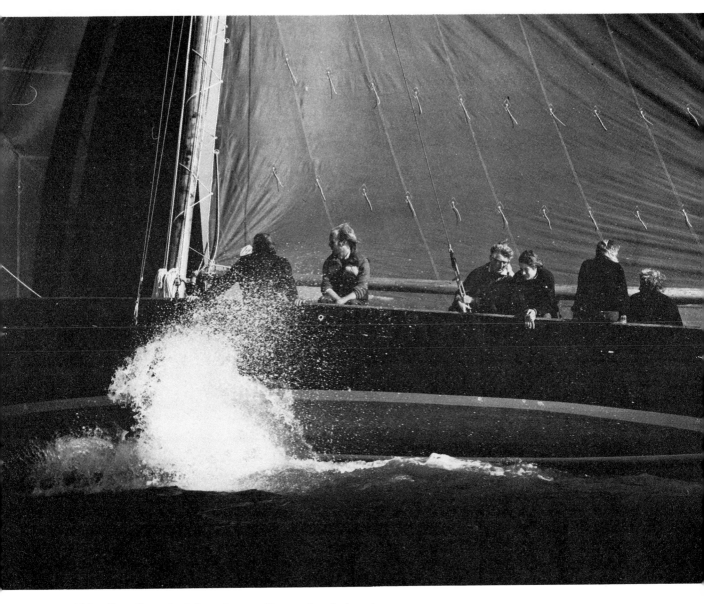

7. *Old gaffer rally in the Solent. Orange filter used to darken the sea.*

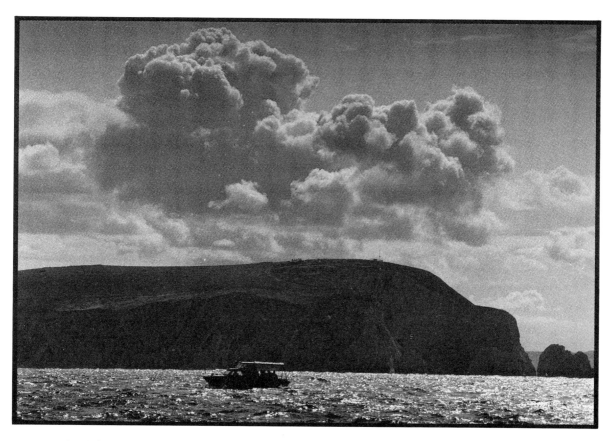

8. *Island clouds: a medium yellow filter helped to enhance sky and clouds.*

2

EXTRA ACCESSORIES

Over a period of time, the working photographer manages to collect a small arsenal of accessories: filters, lens shades, motor drives, charging units for ni-cad batteries used in motors and flash guns, connector leads, pneumatic and electronic shutter-release cables, tripods and monopods, ball-and-socket and pan-and-tilt heads, pocketable torches, electronic notebooks, cleaning equipment, instrument screwdrivers, not to mention the wardrobe of cases and bags that well-travelled photographers seem to acquire. The aim should always be to work with the absolute minimum of equipment. Too many accessories give the photographer too many choices and clutter the mind. The problem, of course, is that from time to time one runs into an unexpected situation that only a special accessory can solve: the expensive cast-aluminium bracket for cramping a camera to the top of a mast, for instance. (Once purchased, the photographer feels such an item must be justified more than once, but if it did the job you first bought it for, it may not matter if it sits on a shelf at home for the next ten years.) You cannot carry everything at once and not everything that you possess is going to be useful on any given assignment.

FILTERS

The most useful accessories are usually filters, especially for black-and-white work. The ability of most modern colour-print film to cope with virtually any lighting situation without a filter over the lens is a boon to professionals. Colour reversal film (for making transparencies) is more delicate and subject to quite subtle shifts in colour temperature. In a marine environment blue light predominates; reversal film will easily pick up all sorts of casts at this ultra-violet end of the spectrum, with quite disastrous results. This was demonstrated while shooting the 1986–7 America's Cup in the antipodes. The light appeared to be fairly constant at first, but over the ocean and away from the land large shifts in colour temperature played havoc with reversal films to the extent that some photographers insisted the only way to reduce the predominant blue effect was to use two or even three filters over each lens. On this occasion I did

not find variation in colour temperature to be a great problem and, after a couple of test rolls, discovered that the application of a single 'skylight 1B' filter was more than adequate and at times not even necessary.

I was a little puzzled why it should be that some photographers claimed to need more than one filter until talk moved around to the various multi-coatings given to lenses to prevent flare. Some of the optics in use simply had different colour coatings and I am sure that it was these variations that were sufficient in some cases to create the unwanted casts. On the whole, modern lenses are so well coated that in European climates such problems are hardly ever experienced except during the early and late hours of daylight, when colours are rendered warmer.

After using the same lens-and-filter combinations in parts of the world as far apart as the Arctic Circle and the antipodean tropics and finding no noticeable or unwanted casts, I am now convinced that the problem arises either from using older lenses with worn coatings, from using entirely the wrong sort of filters and/or a combination of these factors when certain film emulsions are used.

Filters for use with black-and-white and colour film
(* = black-and-white only † = colour only)

Filter	Code no.	Absorbs	f-stop increase	Effect
Clear	1A*	UV	None	Penetrates haze
Pink	2A*	UV	None	Haze/warming
Yellow	2B*†	UV	⅓	Heavy haze
Clear/pink	1B*	UV + blue + cyan	None	Haze/warming
Pale amber	81A*	Blue + cyan	⅓	Lowers colour temperature/warming effect on cold light
Pale brown	81B*	Blue + cyan	⅓	Greater effect than 81A
Brown	81C*	Blue + cyan	⅔	Greater effect than 81B
Pale yellow	3†	UV + blue	⅔–1	Darker blue sky
Yellow	4†	UV + blue	1–1½	More effect than yellow No. 3
Light orange	21†	Blue + green + cyan	1½–2	Pronounced dark blue skies/improves contrast
Red	25†	Blue + green	3–4	Blue skies go black/dramatic increase in contrast
Yellow–green	11A†	Red + blue	1½–2	Improves skin tones/lightens sea water
Dark blue	43 and 47†	Red + green + yellow	3	Improves tones in sea water/dramatically heightens haze

In the field the most commonly used filters for colour reversal films are an ultra-violet-absorbing skylight 1A or 1B. The latter has a slight warming effect on most colours and some photographers find this preferable to the colder rendition provided by the 1A. For black-and-white work there are innumerable filters which can be useful: yellow, yellow-green, orange and red all absorb blue light in varying degrees. Because panchromatic emulsions are more sensitive to blue light, using the lens without a filter results in negatives with washed-out blue skies, i.e. skies and clouds that appear on the negative as black, over-exposed masses. These are difficult to print at the best of times and satisfactory results are nigh impossible in the hands of a printer who has no idea of the tones which should be represented. To be on the safe side, a light-yellow filter used on the lens all the while that black-and-white stock is being exposed, will make an enormous improvement.

A wide range of coated optical filters are available at moderate cost to fit the most commonly used lens sizes. The most popular in Europe are those made by Hoya Glass and in America, by Tiffin Inc. More expensive types are manufactured by the camera makers using optically dyed glass. I have a large collection of the two types and unless prints were produced under the most highly sophisticated laboratory conditions, I doubt whether anyone could tell which filter type had been used. Dyed-glass versions are so expensive as to be almost prohibitive and are easily damaged, the most effective abrasive being dried salt. Given the choice, I would rather spend the money on a good polarising filter.

Polarising Filters

When used properly, a polarising filter can increase colour saturation and apparent sharpness by eliminating unwanted specular reflections. It can be used to darken sky tones in both colour and black-and-white photography and, because of its ultra-violet absorbing qualities, can also be used to cut through sea haze and eliminate bluey casts. An increase in exposure of 1–2 stops will then be necessary.

If the filter is held to the eye and then rotated slowly in one direction, it will be seen that the reflections from the subject being viewed are almost totally absorbed. Further rotation will restore the reflection as seen normally by the eye. Used on the front of a lens, the filter has exactly the same effect on film, allowing the photographer an infinite number of selections before exposing the film.

Other Filters

A variety of other filter types has become available in recent years. These

include partially coated acrylic resin filters, produced in the shape of squares which fit into special holders. Invented by a Frenchman called Jacques Cokin, they have collectively been given his name, even though different manufacturers produce them. The Cokin-type filter is available in many different colours and configurations and is used mainly for special effect, to add colour where there is none, to add optical effect such as star bursts, multi images, parallel lines, softening effects and so on. The possibilities are only exceeded by the limit of the photographer's imagination.

I have found that certain filters work quite well to darken the sky on the sort of muggy day when normal exposure would have produced a fairly flat and lifeless negative. However, I was not at all happy with the results achieved in colour. Indeed, although some photographers enjoy the results produced with these filters, I believe that most of these filters are no more than the kind of gimmick that will appeal to the lazy mind, producing an image which is too artificial for my liking. But don't let that stop you, I am sure that with a little persistence, someone will get the effect right!

THE MOTORISED CAMERA

There was a time when the photographer who was able to turn in one sharp picture of an event was usually well pleased with his luck. Today, picture editors seem to need more choice; furthermore, picture agencies and libraries have such huge international client lists that one frame is simply not enough to satisfy all of their needs, even allowing for the fact that duplication can reproduce that shot many times over. The camera motor drive has been developed to enable the photographer to achieve more than the basic quota of sharp pictures of events that take place in seconds. At the same time, by exposing a succession of frames at high speed, the subject will be caught in perfect sharpness at the most animated moment.

Most observers unfamiliar with the sport of yacht racing would probably, and not unnaturally, consider it to be a fairly sedate spectator sport. In reality, given a good breeze, yachting can be as exciting to watch as any other fast-moving sport: dinghy racing in a blow is laced with enough capsize and mishap to ensure the dedicated observer is glued to the camera viewfinder; rounding the mark provides a spectacle of colour and action; and heavy weather over the ocean can often provide sufficient action to keep a photographer well poised. In many instances, it would be perfectly possible to cope with most of these situations without a motor drive, but the chances of actually getting the picture are usually much improved with, rather than without.

Today's motors are far more sophisticated than the early versions which featured on cameras like the Nikon F. They are quieter, more reliable and mostly more compact. A true camera motor advances the film at the rate of more than three frames per second, has a facility for rewinding the film and can be operated in single-shot or continuous mode. Some motors can also be operated by other electronic controls which might be set up at a distance from the camera. The more simple winder – also an add-on accessory – advances the film at a much slower rate and does not usually have the sophistication of a true motor drive.

Due to their relatively complex electronics, motors tend to be more expensive, somewhat bulkier and in many ways more useful than a winder. When extra-long telephoto lenses are employed, the camera often needs the extra weight of a motor to improve handling and balance; the extra weight also helps to absorb some of the additional vibration in the mirror box set up by the motor when advancing the film at a rapid rate.

The cost of the motor aside, the obvious factor to be taken into account is that, if you use a motor regularly, you will notice a dramatic increase in the amount of film that passes through your camera. For example, you find yourself positioned happily in the middle of a long line of yachts about to start a race and it is blowing a howling gale. Just about everything, including the kitchen sink, seems to be flying past your camera or directly at it. What do you do? One or two frames are certainly not going to be enough to capture the essence of the moment unless luck, circumstance and knowledge of a developing situation are combined at the precise moment. Instinct compels the experienced photographer to keep looking and keep pressing the button until some other instinct says that more will only be less.

In another situation where it may be simply a matter of shooting someone's portrait, the motor drive may or may not be an asset. If only one good frame is required, the winder can be cranked by hand and the exposure made in more deliberate fashion. The professional may require more than one frame and in that case, a motor or winder will be useful, but not having one does not prevent those extra frames from being shot.

The final decision will depend on how you as a photographer prefer to work. If you use a camera that can be fitted with an optional drive, the chances are that you will use one anyway, if only on the basis that you feel the camera will benefit purely in its handling characteristics when long, heavy lenses are employed. If you use a camera fitted with an integral drive, the argument becomes erroneous. Either way, learn to use the motor as an additional tool to help make better pictures and not simply as an accessory for eating up miles of film.

EXPOSURE METERS

In the marine environment it is likely that some form of exposure meter will be needed in addition to the integral exposure control with which most modern cameras are fitted. A sophisticated 35 mm SLR camera will not only be equipped with a fully computerised in-camera meter, but it may have several exposure functions that can be selected at the flick of a switch.

In their simplest forms, these functions can be switched between manual and automatic, and vice versa. Some cameras also have a fully programmable mode which the user sets to 'P'. From here on, the camera selects both shutter speed and aperture. The combination selected however, may not be displayed in the viewfinder in its entirety. This might be irritating for the photographer who is relying on the camera to select a preferred range of shutter speeds rather than the highest feasible f-stop number. In this case, the 'programme' method of evaluating exposures will be of far less use than a more sophisticated 'automatic' or 'manual' mode, though in fairness it has to be said that the Ricoh Camera company have produced some superbly sophisticated programme type SLRs in their XR and XP range.

More sophisticated meters are to be found in higher priced SLRs such as the Canon T90, the Olympus OM3 and 4Ti, and the Nikon F4 and F801. The meter in the Olympus can be switched from manual operation to auto and in this mode allows the user to select a general reading of the scene or to use the camera as a sophisticated spot meter, taking readings from both shadow and highlight areas of the scene which are then computed by the camera. This meter can be used in a variety of ways, even as a simple zone-system meter. But more about that later.

If the photographer's system is based on 35 mm only, it is unlikely that a separate hand-held meter will be required. Medium-format cameras like the Hasselblad, however, are manually controlled unless a separate exposure-meter prism head is used. A metering prism is not a necessity for this type of equipment, but the photographer will need some kind of exposure meter. Ordinary studio light meters are very vulnerable and do not last. The Weston Master is small and pocketable and very accurate. However, in the marine environment, it pays to have the best; the best, in this case, being a dedicated marine meter called the 'Sekonic Marine'. This meter is fully enclosed in a gasketed watertight housing and is battery operated. It can be set for a variety of ISO speeds and displays an aperture to a set shutter reading. It was originally designed for use under water and because of this has a very narrow angle of view. It is exceptionally accurate, even if the subject is a long way off. I have used one of these for over 10 years now. If I am ever in any doubt as to the reading displayed in a

camera viewfinder, I can usually rely on the Sekonic to give me the correct exposure. (Incidentally, it works just as well on dry land, even for subjects such as macro-photography.)

Making correct exposures for a whole range of lighting conditions is discussed at length in Chapter 3. As far as actual equipment is concerned, the only other comment which should be made at this point is, always ensure that the power supply to your in-camera or hand-held meter is in tip-top condition. Flat batteries are one of the main causes of poor exposure or equipment which fails when most needed.

EQUIPMENT PROTECTION

Camera Straps

One incidental item which is important, although seemingly minor on the face of it, is the ubiquitous camera strap. Whether you are a serious enthusiast, intent on using the camera frequently, or someone about to cross the threshold into the professional world, the only physical link between you and the finely engineered piece of equipment for which you have just paid is the strap – representing but a fraction of the total cost.

The more expensive camera comes with a well-made strap, designed to take the heaviest weight the camera can support. It may not look much, but, properly fitted, it will invariably be much stronger than the fancy accessory types which are often poorly made with single stitching and the occasional rivet. Rivets tend to weaken rather than strengthen a strap, unless the material used is a heavy-gauge leather providing plenty of material around the point of insert.

Always inspect the metal clasp which fits to the camera eyelets. The metal used in some instances is often suspect and I would not trust it for use as a cat lead, let along to hang my camera or lenses on. On one occasion, I purchased what I thought to be a heavy-duty spring action fitting of the type used in dinghy rigging in order to fit a strap to a telephoto lens weighing 3 kilos. The nylon webbed strap came from a reputable camera maker and the fitting was purported to be best quality stainless steel. After only three months' use, the fitting snapped off at the swivel allowing lens and camera to crash to the steel deck of a photo-launch I was working from at the time. The lens was badly damaged and landed me with an expensive repair bill. On inspection of the fractured clip, it was obvious that stainless steel had not been used in its manufacture; a low-grade alloy, cleverly polished to make it look like the real thing, was at fault.

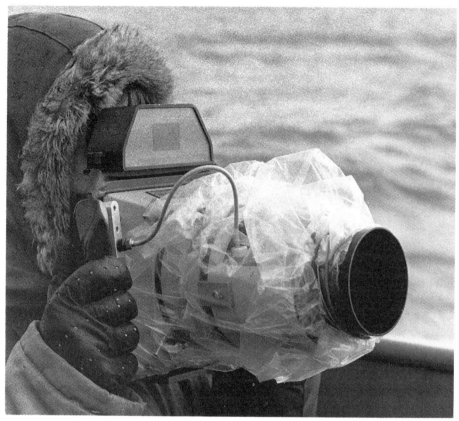

Keeping gear dry is the marine photographer's biggest headache. A polythene bag, tape and elastic bands often work better than customized pockets, and cost a lot less.

In the marine environment, any metals that are not of the non-ferrous type corrode quickly. If you do not want to use straps supplied by the maker, you could have special ones made up by a saddle maker. I have had many of these made over the years and they have lasted well, but they are, as in the nature of hand-crafted items, expensive.

A good-quality strap is probably the least you can provide in the way of equipment protection. The most expensive extra on the list however, is a bag in which to carry the armoury of lenses and bodies.

Baggage

Conventional camera cases and gadget bags come in a variety of sizes. Most are made with a tough synthetic outer skin, padded with foam, lined and provided with movable foam-padded inserts to prevent cameras and lenses banging together. These can be purchased as a basic unit and then

transformed by the addition of zip-on bags, self-fastening pocket inserts etc. into the most elaborate of high-tech containers. Billingham and Tam-rac make a range of bags which are, generally speaking, good value for money.

A soft bag is always useful as a lot of gear can be crammed into it, if necessary. However, if you are planning to travel far and wide in the quest for marine pictures, take only what you can reasonably manage in a soft bag. Use an aluminium box or trunk for the rest.

Good-quality aluminium and some resin-moulded boxes are usually worth the extra money you will have to pay. They provide ample protection from the kind of knocks and bangs that equipment in transit seems to suffer over a period of time. Hakuba or Halliburton aluminium cases are available through most photo-dealers and are sold with ready-to-cut foam inserts, or slottable partitioning.

Flat suitcase types are available in various sizes, including ones that are designed to fit under an aircraft passenger seat. However, as they need to be opened in a clear, flat, space they can be inconvenient for use on a boat. The overall structure is strong enough to take the weight of an average man when the feet are placed along the edges or the box is used in its upright position. The large flat panels are vulnerable to knocks from sharp objects, however, and if the owner is in any doubt about the suitability of such a case, it would be better to invest in an impact-resistant case such as those produced by Pelican. These are waterproof, dustproof, and float when fully laden.

Another type of case which has proved popular among well-travelled marine photographers is the lunch-box/camper-cooler. These boxes are a little larger than most aluminium types, are moulded from tough, double-skinned PVC, are light, reasonably waterproof and cheap. Try to find a cool box with strong metal clasps at either end, or the type of heavy construction that could be fitted with spring-loaded, lockable clasps available from most good hardware stores. In the event that your photo-boat sinks from under you (yes, it has happened!) the camper box and its contents are quite likely to fare reasonably well and, because of their bright colours, are easily spotted bobbing on the surface of the water.

An all-too-common occupational hazard with which the photographer sometimes has to contend is theft – usually from cases during transit between aircraft but equally from cars or from the luggage rack of a train. The use of the conventional type of bag, box or case invites attention from the outset: everyone knows a camera case when they see it. Manufacturers could surely make use of the wide range of coloured waterproof fabrics available and help alleviate the problem of theft by producing a brightly

coloured rucksack-type bag, rather than the existing drab grey or khaki bags which seem to be the norm.

In the absence of such gear, a good-quality backpacker's rucksack lends itself to conversion to a practical equipment bag, since it incorporates a number of features that are useful in the marine environment: waterproof fabric, long exterior side pockets with protective flaps, waterproof sack lining, double stitching and so on. The user should select a pack of between 35 and 55 litres capacity which incorporates a light tubular aluminium frame for stiffening.

All that is then needed is a thin foam mattress (available in 12 mm and 15 mm thicknesses from camping outlets) to line the backpack; a roll of waterproof adhesive-backed tape (from all good upholsterers) to secure the mattress to the sides of the pack and pieces of thicker foam rubber (7 to 10 cm) fitted into the back of the pack and wherever additional protection might be needed – bearing in mind the effect this will have on the overall capacity of the sack. The surface of the foam rubber adheres readily to the gaffer tape and, if removed from the tape at any stage, will probably tear, so be careful to use a paper pattern in making the shapes to be cut. Use liberal amounts of tape in securing the foam to the inside of the bag and to itself.

CAMERA PROTECTION

The sleekly contoured body shapes of some modern SLR cameras such as the Canon T90, the 620, the Olympus OM 101 and others are ideally shaped for reasonably efficient waterproofing. More conventional camera designs, with protruding knobs, buttons, sharp corners and vulnerable gaps between body and clip-on accessories, are much more difficult to secure from the all-pervading salt atmosphere, or worse, buckets of salt spray. Manufacturers of some of these models – the Olympus OM3 and 4Ti, the Pentax LX and the Nikon F4 – have sealing gaskets added in manufacture but although a huge improvement, these seals do not keep out the worst weather.

In its simplest form, protection for the camera and lens in use can be provided by nothing more elaborate than a polythene bag and an elastic band. The front element of the lens protrudes through a hole in the bag and is covered with a high-quality filter of the photographer's choice. If the filter gets wet enough, it is usually not too expensive an item to replace after a season's work, but the main body of the camera will be well protected.

When I first became involved in this caper, I tried various other protective devices. One of the easiest to apply is a spray-on silicone wax such as Scotch or Protosil, available from retailers specialising in mountaineering and camping equipment. This dries to a semi-hard finish and, because of the ease of application, a camera body can be reasonably proofed against the elements and light salt spray. After several applications, various parts of the camera become gummed up with wax which should be removed and the camera cleaned down so that fresh applications can be made. Lenses and viewfinders should not be sprayed. The easiest way to ensure that wax does not penetrate these areas is to tape them up with paper before applying the wax. Once the wax has dried – usually overnight – the paper can be removed.

I still use this system from time to time, especially when I know for certain that conditions on or near the water are liable to be wet and miserable. What prevents me from using it all the time is the inevitable build-up of wax and dust which collects after several applications and which then takes hours to clean off. However, the alternatives are in many ways just as impractical. The liberal application of gaffer tape over the whole camera until it resembles a bandaged patient has been known to save a camera or two in the worst possible conditions a photographer is likely to encounter or want to shoot under. To ensure total waterproofing, everything must be taped up, which means that shutter speeds and apertures can only be changed with difficulty.

A method I prefer with medium-format cameras is to use a bag made of heavy-gauge polythene and which is large enough to allow the hands to move about freely. As light conditions at sea tend to remain constant for much of the time, even when there is some cloud cover, exposures remain constant, too, so the only adjustment which has to be made frequently is focus. Working at close range to the subject with wide-angle lenses from a small inflatable dinghy has often brought gallons of water leaping over the sides, but the polythene bag has always managed to save the day.

The contoured modern cameras that have all their controls slightly recessed or hidden behind opening flaps can easily be sealed with gaffer tape or clear 3M repair tape. The latter is a heavy-duty polythene-based adhesive tape which can be used to cover the LCD window displays while still allowing the user to read relevant information. It is not usually necessary to tape up the whole camera; these sleeker bodies have fewer protruding vulnerable knobs and buttons and can easily be proofed with the clear tape. It is readily available off the shelf at supermarkets, stationers and other retail outlets.

41

This leaves only the problem of protecting the barrel of the lens. Custom-made covers with Velcro tabs can be purchased through some photo-retailers in the United States. Some camera manufacturers have produced 'rain' covers for their equipment. As a last resort, the photographer who has access to a sewing machine might be able to stitch together suitable covers made of light waterproof nylon or terylene materials which can usually be acquired from a sailmaker's loft at not unreasonable cost.

PERSONAL PROTECTION

I learned my first serious lesson about personal protection while covering a story on the Royal National Lifeboat Institution's Inshore Rescue Service. The boat I was working on was a high-speed 18-footer which normally carried a coxswain and a crewman who operated from the relative protection of a semi-enclosed steering position. It was a bright but very windy day; ideal for the pictures I wanted to shoot and hopefully get. The coxswain insisted that I don a full RNLI waterproof and life-jacket before we set off. I was not used to this and complained loudly that it would be difficult for me to work properly while encumbered by a heavy suit and puffed-up life jacket. My protests were in vain. If I wanted to go to sea with them, I would have to wear it and that was that.

We set off and almost immediately began to bounce through a heavy chop at the harbour entrance. About a mile offshore a sandbar was half obscured by a seething mass of foam and water; the sea around it was very confused, piling up every which way. The coxswain said he could take the boat around the edges of the bar but that it was liable to be uncomfortable. I believed him, but the only way I could shoot the pictures I wanted were from the bow of the boat looking back at the two men. By securing me with rope lashings to the forward rail, we all felt sure that if I could keep the camera steady enough for long enough, I might get lucky. We found a relatively quiet patch of water so that I could get in position and be tied down; I didn't like the lack of freedom but for the sake of the occasion I had no choice and we set off into the fray.

When a high-speed boat of this type hits bad water, it tends to want to fly. The landing is hard and can do a lot of damage to men and machines. My precarious position on the bow was about as uncomfortable as I think I should ever wish to endure, but we were all committed to the task at hand and backing out was the last thing on my mind. I got the picture I wanted but ended up straddled across the bow, half hung over the side, having my hair shampooed with every dive the boat took. It all happened

so quickly I had no time to think about grabbing a rail. One moment I was tied in, the next trying to get airborne and coming down with a back-breaking thud across the sharp end of the boat. Apart from some pain in my spine and a couple of bruised ribs from the rope lashing, I was alright and after an hour or so ashore in the hut where I recuperated over hot grog, we all three set off again to rendezvous with a helicopter for a practice rescue.

With the best pictures of the day in the can and not many results from the helicopter, my mind fell to concentrating on how to justify more expense on the kind of protective clothing that might help to reduce the possibility of broken bones and getting uncomfortably soaked to the skin everytime I went to sea.

There is now such a vast array of well-designed clothing that the photographer is really quite hard put to decide what is the best. A light-weight one-piece suit is useful in warmer climates, but it should have some sort of lining that helps to reduce condensation or be made from Goretex which is both water- and sweat-proof. At the present time, I use a specially adapted one-piece suit with large flapped interior pockets for lenses and film manufactured by Henri Lloyd in England. This suit is a little heavier than I would have liked, but it is double lined and protection against the wettest conditions. It has an integral hood which rolls out from the collar when required and is secured by zips and Velcro tabs. Underneath this I wear whatever is necessary for the occasion. A cold-weather one-piece suit of the type available to the oil industry is a useful extra and provides additional padding and protection against knocks and bruises. A life-jacket is essential, when going afloat, especially if you are working from a small boat or sailing dinghy. A user-inflatable type which can be worn discreetly under a heavy weather suit is called the Lifeguard Compact One and complies to BS 3595. A partially filled jacket need not be very bulky and provides yet more personal protection. Another advantage is that this type of life-jacket can be quickly deflated and rolled up to the size of a folded tea towel for storage in a gadget bag. Other types of life-jacket which incorporate bulky fillings are not suitable and the ones with CO_2 cartridge-inflating devices need to be checked out occasionally to make sure they work – a lot of extra work which the marine photographer doesn't need.

Finally, there is the question of footwear. Yachtsmen's shoes of the lace-up moccasin variety are fashionable, but not very practical. Good-quality trainers with fairly soft composition soles will grip well on the decks of most small boats and yachts. Rubber or composite vinyl sea (wellington) boot types are useful. A good one-piece suit should have leggings which

pull over the boot and are secured in place by an inner legging elastic. An ordinary unfashionable pair of wellington boots are useful for plodding around creeks and estuaries.

The author covering sailing Olympics off Pusan, South Korea, dressed in one-piece weatherproof suit. These should be lined and fitted with flapped internal pockets for film and lens stowage. Knee and elbow pads are sometimes worn under heavy-weather gear for further protection against shipboard knocks.

On bigger ships and commercial working boats, the kind of clothing a yachtsman might wear, apart from a really good one-piece foul-weather suit, is of little use. A good pair of (at least) ankle-length leather boots is essential because there is usually so much junk built into the steel decks of these ships that any contact with it in less than a tough working boot is liable to result in more or less permanent damage to one's feet. Losing one's footing on steel-plated ladders is not a pleasant experience and it is usually a long drop to the next deck.

Whenever an assignment on a tug or salvage vessel comes along, I try to take much more than I would normally need in the way of clothing. To begin with, the stay on board is likely to last several days, if not weeks, and it is always possible that locations may vary from one climate to another. The nature of the assignment should tell the thinking photographer what is likely to be required and there is no excuse for arriving on a barge designed to haul wrecks off the sea-bed looking as if you are off on a cruise to the South Sea islands!

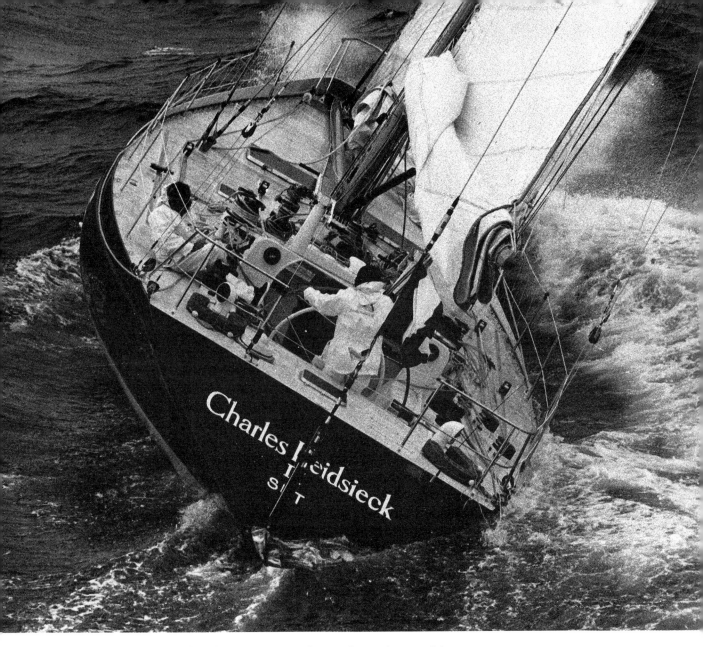

9. *A medium telephoto lens (200 mm) used to emphasize the size of the yacht and dramatize the state of the sea by compressing all the elements.*

10. Jade *crew make emergency repairs. The photo-boat helmsman's
quick response to the situation helped the photographer get the picture
without hindrance to the yacht. Novoflex 400 mm.*

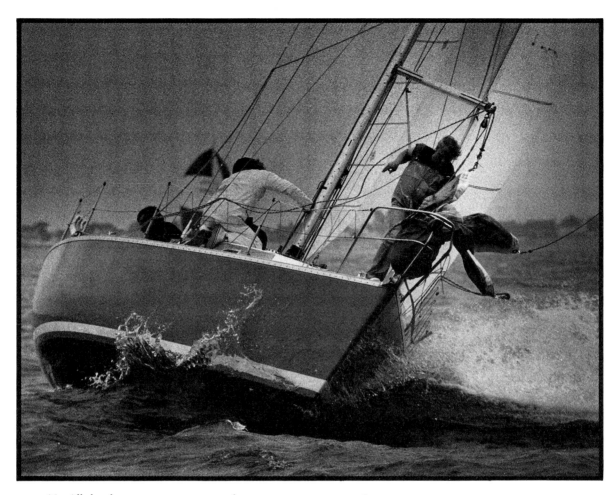

11. *All the elements must come together at one moment to produce animated racing pictures. Novoflex 400 mm.*

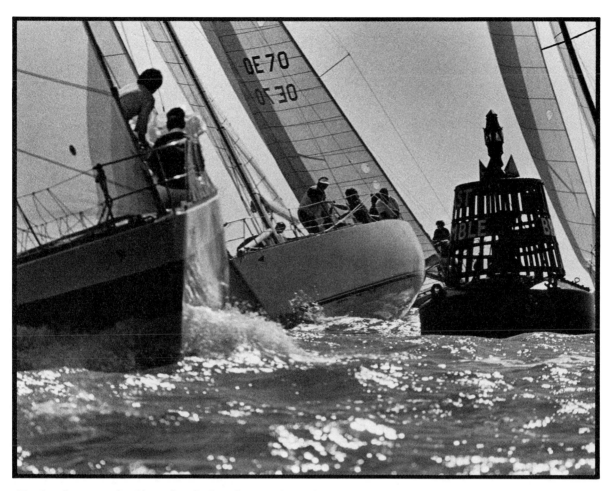

12. *Another example of how the telephoto lens can be used: space between the yachts and buoy is compressed to give the effect of more action.*

13. *Silver Jubilee Review: ceremonial and other 'Navy Day' events can produce useful library stock pictures.*

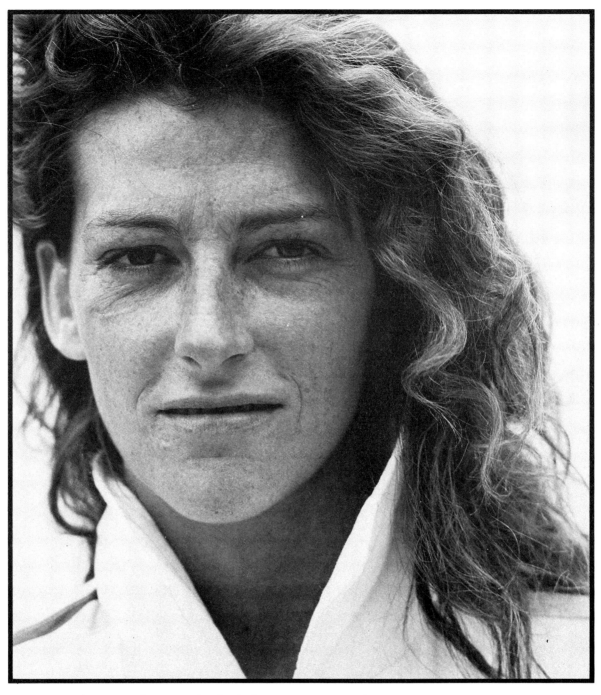

14. *Yachtswoman Florence Arthaud – the human visage, as so often, making a powerful subject. Daylight field studio, 6 × 6 SLR with 150 mm lens and extension tubes.*

3

A SENSE OF SEAMANSHIP

The key to consistent success in marine photography, as in any other subject, can be summed up in a word: knowledge. Of equal importance, however, in producing consistently high-quality pictures is the ability to plan ahead. In this chapter we investigate these two aspects of the craft of marine photography.

KNOWING YOUR SUBJECT

On the ocean not only are there rules of the game to learn (about racing for example), but, in addition to this, a knowledge of the art of sailing is needed: why one particular boat is going one way and the other in an apparently opposite direction; the effect of tides, prevailing weather conditions, direction and strength of the wind, whether the front looming on the horizon will change the photographer's luck or whether it is a good indication that an early end to the day is in sight, and so on. All this is quite apart from an elementary knowledge of why certain types of craft do certain things: why, for instance, does a high-speed destroyer lean outward when turning when a smaller patrol boat and some types of high-speed pleasure craft lean toward the turn? What makes a sailing boat move through the water and why do some appear to fall over and others not?

From a photographic point of view, not all questions as to why certain craft perform in certain ways need an answer; the observant photographer with lightning-quick reflexes will shoot first and ask afterwards. A power-boat leaping into the air off a wave crest or a big ocean racing yacht broaching in a squall needs no explanation; but the photographer who is armed with a little extra knowledge which may give an insight to when certain craft may suddenly leap skyward has an edge on timing. It is this factor more than any other, combined with an ability to see the picture before it actually happens, that makes the difference between great and mediocre work.

An example of this occurred for me some years ago as a race for class I ocean racers was about to begin off Cowes. I use this particular example because the resulting picture has been labelled as something of a classic by

a variety of editors who have seen fit to use it and it does illustrate quite well how a thorough knowledge and understanding of the subject can improve the photographer's chances.

This race day began calmly enough, with many yachts milling around the start line area a good half-hour before the gun was due to be fired. I was embarked on a biggish motor cruiser with another photographer and a handful of friends. We had no real intention of following the race that day and were idling around the Royal Yacht *Britannia* some distance off the Cowes starting line, watching the comings and goings of royalty and guests.

When the preparatory gun for the race was fired our heads naturally turned in the direction of the start area. A good south-westerly breeze had sprung up. Yachts were beginning to pile up in the start area, reaching up and down the line as the minutes ticked by. Our helmsman had swung around so we were now drifting on tick-over slowly toward the line, but still a good way off and in no position to interfere. All on board were crammed onto the tiny flying bridge, lazily soaking up the sun and counting off the minutes to the start.

By now, a great long line of yachts stretched nose-to-tail from the outer marker to the shore, their sails flapping like a school of mackerel. A minute to go before the gun. I glanced across to the royal yacht and the guardships now slightly astern of us. One single yacht, a big ocean racer with all sail set and a bone in her teeth, was tramping up toward the line. A lookout stood on the foredeck, hand on forehead in the manner of a peaked cap. She had about 400 metres to go to the line which by now was thick with yachts stopped dead in the water as they luffed away the last few seconds. What was odd was that the yacht had more speed on than was necessary to reach the line on time. I couldn't see a hole anywhere in the line. What would this loner do? She'd have to tack surely; the lookout must have told his skipper there was no room to pass.

Something about the attitude of the yacht and its apparent determination to break through the solid wall of hulls ahead didn't seem right to me. Instinctively, I raised the camera to eye level and focused. Whatever the rest of the fleet did now didn't really matter; this fellow appeared to be intent on a collision course. I shouted to our skipper who then, with the rest of the crew, began hollering at the fleet. The engines roared into life as we made a bee-line for the offender, but we were too far off. I kept the camera glued to my eye, searching for a gap in the fleet which I was sure must be visible to the skipper of the offending yacht, if not to ourselves. There was no hole. I squeezed off a few frames and watched through the lens as first the yacht's pulpit dented her victim's foresail and then her

sharp bows began to climb aboard the other's hull. A few more frames and I had the whole sequence. By now, there was pandemonium in the immediate vicinity of the collision. A terrible renting of sails and the noise of splintered wood filled the air as spars crashed to the decks.

Collisions between racing yachts are not uncommon, but they are difficult to interpret in a spectacular photographic manner. You have to develop a keen eye and sense of timing for what is happening on the course within photographable reach. The moral aspects are fairly straightforward: yachts which are racing must not be interfered with even when observers close by see a nasty situation developing. Yacht-racing skippers know exactly what they are doing and the risks involved. Off the course, it's a different matter. Assistance which might help prevent a collision should always be rendered whenever possible.

Ocean-racing yachts: Modern yachts are a very different shape from their older predecessors. They have hulls whose underwater shape resembles more a skimming dish than a knife on edge. They still have keels to keep them upright and rudders hung on skimpy appendages at the stern. The skimming dish tends to bounce through and across the surface of the sea. These craft act like surf boards in a good down-wind blow and, if the sea is big enough, quite a lot of the hull will come out of the water from time to time.

Classic sailing boats: Designs of years gone by put more of the boat below the water than above it. Consequently, sailing yachts of this type tend to bite deep into the water and pitch heavily in a seaway. They tend to adopt the classic 'sailing on their ear' attitude with which most of us are familiar. Their freeboard, the amount of hull normally out of the water, sometimes vanishes beneath the waves on the leeward side, the opposite side from which the wind blows. They do not surf very well but are usually more stable than their modern counterparts which are often difficult to control when running downwind.

High-speed motor cruiser: The hull shape is the key. Most high-speed cruisers have a V-shape bottom and flattish sides (topsides). The less 'V', i.e. the flatter the bottom, the flatter the boat's wash at high speed; but it is liable to bounce harder on smaller waves than its deeper-V'd counterpart. Most modern offshore motor cruisers have deep-V'd hulls and can travel at high speeds in fairly rough weather. They do this by skimming over the surface of the sea and, as a consequence, are subject to its constantly changing undulations. The faster the boat, the more dramatic the effect when its hull slams into a wave.

The displacement hull: Similar in shape to that of the typical fishing boat. The rounded hull form sits well in the water and tends to bob about a lot

less than the skimming dish or high-speed powerboat. Displacement-type boats plod around at 'respectable' speeds, pitch and roll in a seaway but rarely do much that is dramatic unless they are large commercial or naval craft.

The naval destroyer has a displacement-type hull, but stretched to the limits of sensible naval architecture. 'Long and thin', it is easily driven through the sea at high speed and performs dramatically when charging through a gale-torn sea. As destroyers are very buoyant at the ends, they tend to lift easily to the swells, the bows slicing through and out of the sea as a crest is climbed.

The average *bulk carrier* or *tanker* has a more barge-like displacement hull and acts in a manner one would expect. With enough horsepower, the barge tends to crash through heavy seas when heavily laden with cargo. The freighter or container ship is more refined, a lot less barge-like, with a sharp and elegant stem that helps it to slice through the waves. However, these ships can roll and pitch just as dramatically as the high-speed destroyers, given the right conditions.

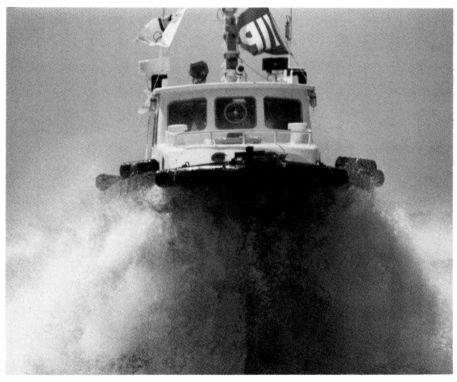

A conventional, semi-displacement hull tends to drive through the water rather than over it, and requires almost twice as much power to achieve the same speed as the surface running boat. However, it can maintain its speed for far longer in heavy weather.

56

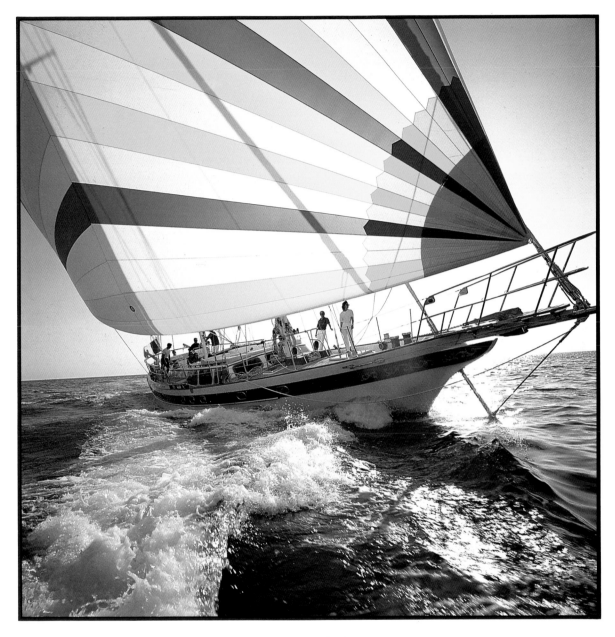

1. *Not everything which works well in black and white will work in colour; light and colour need more careful consideration. Sailing off La Baule.*

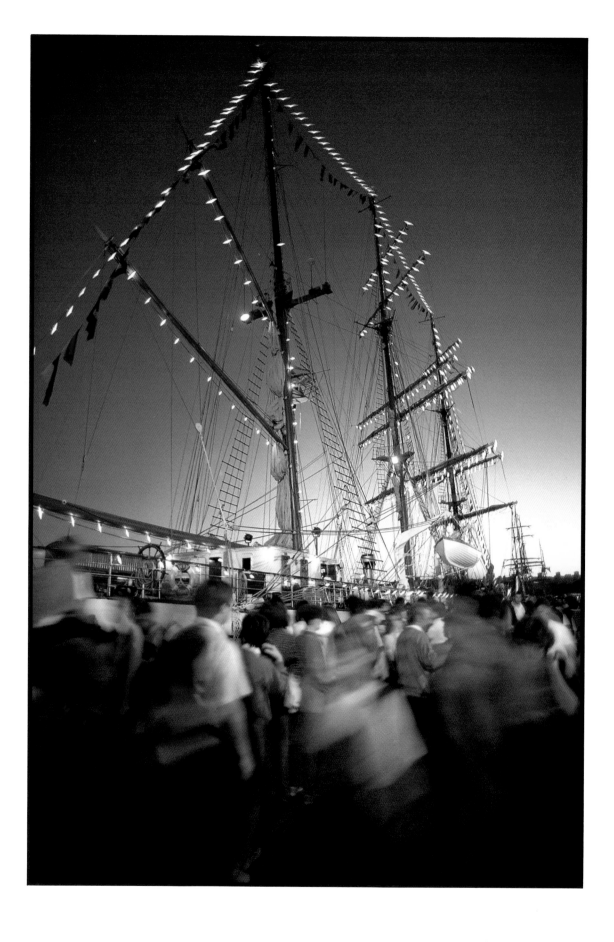

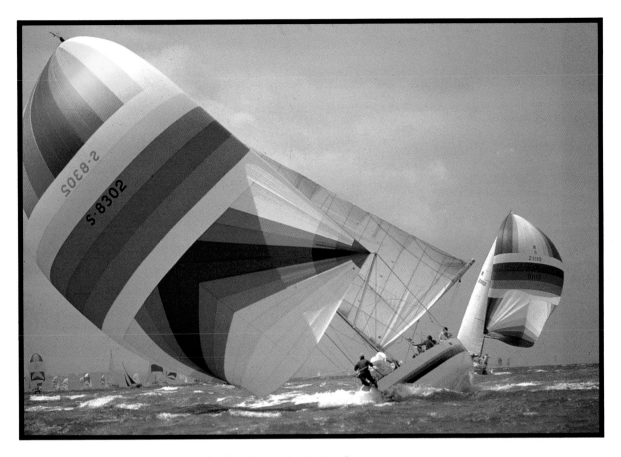

3. *Admiral's Cup regatta, Cowes, Isle of Wight.* Midnight Sun *dances to the breeze.*

4. *Custom shot for advertising. It helps to have a graphic brief before shooting begins. Helmsmen should be experienced and have nerves of steel. OM4Ti SLR, 17 mm lens.*

2. (LEFT) *Evening on the quay at Rouen. Tall ships provide a never-ending source of picture material and are easily accessed.*

6. *Monochromatic colours – late afternoon on the Norfolk Broads.*

7. *Racing through the Klongs of Bangkok. 17 mm lens and slow shutter speed achieve the desired effect.*

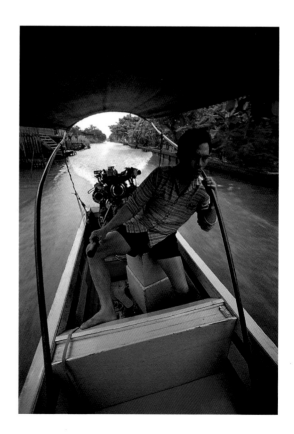

5. (LEFT) *Windsurfers are more commonly shot from the beach with long lenses. This one was captured from 500 ft up with a Novoflex.*

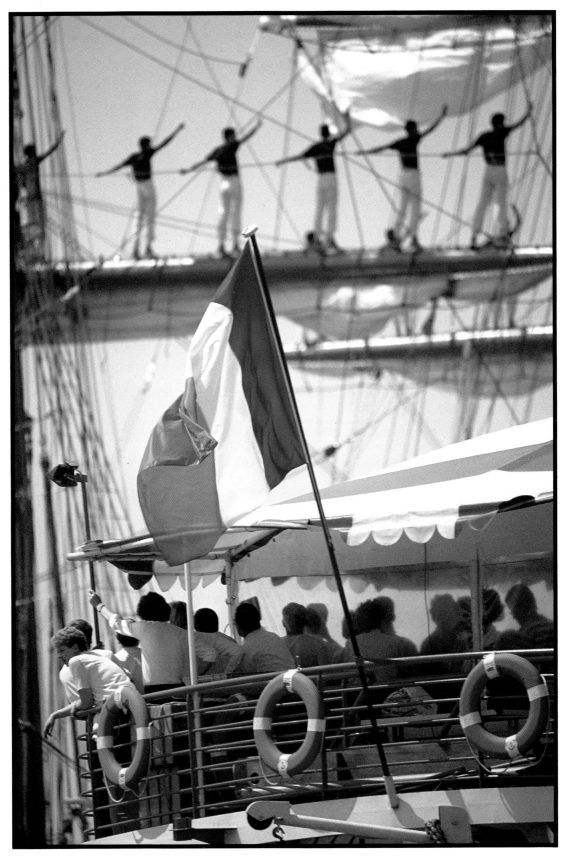

8. *Watching the tall ships. Deliberate out-of-focus background with
500 mm lens adds depth.*

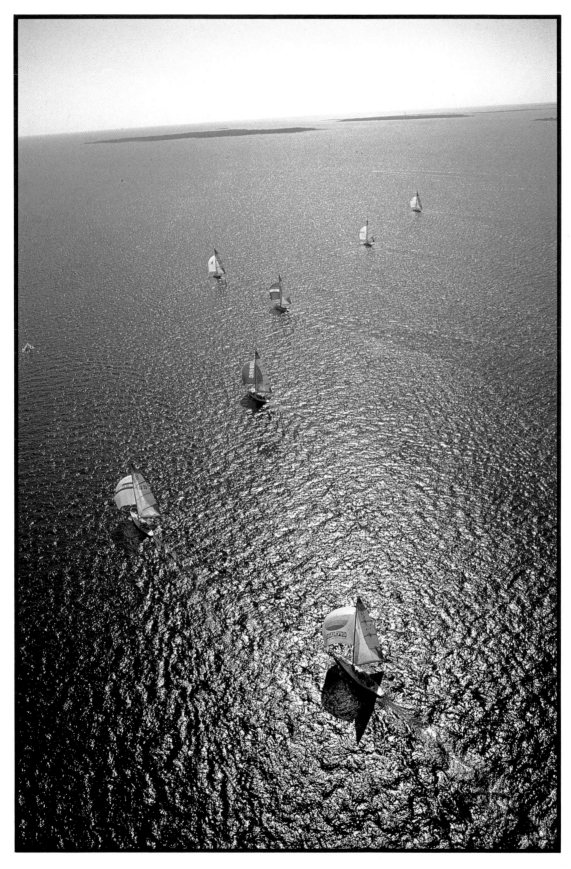

9. *Not all aerial shots require telephoto treatment. Twelve-metre world cup event in the Baltic. OM3 SLR, 40 mm.*

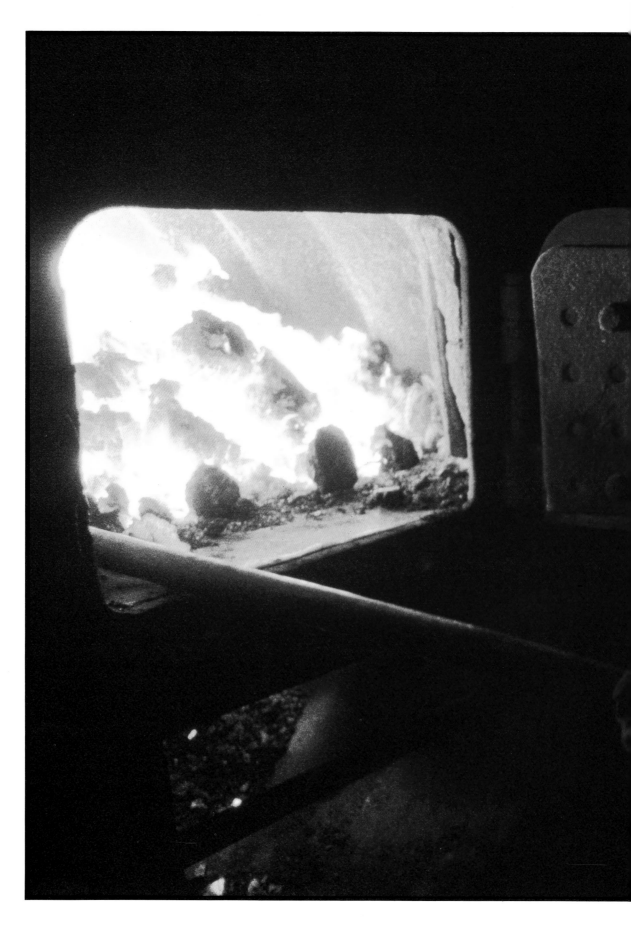

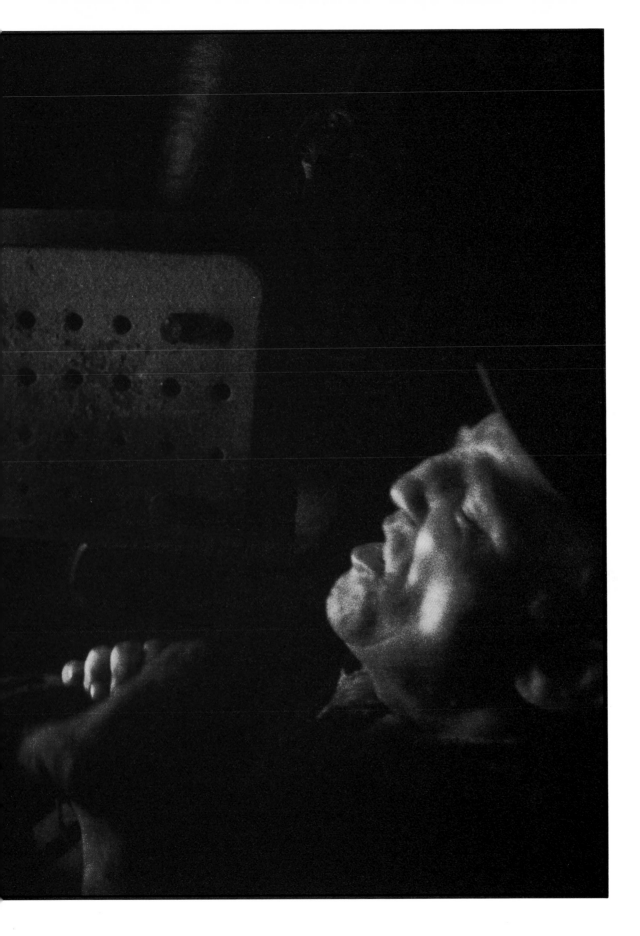

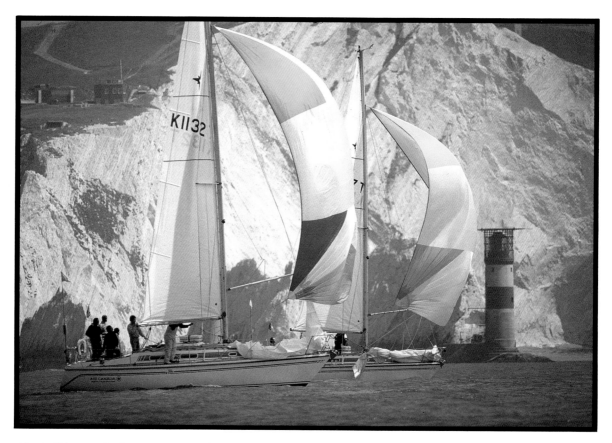

11. *A 500 mm telephoto lens and shallow depth of field concentrates the eye and gives correct proportions to the background.*

12. *There is no reason why a 'marine' photographer should always go to sea. Different viewpoints abound ashore, and here London's Tower Bridge forms a perfect frame for tall ships moored below the pool.*

10. (PREVIOUS PAGE) *Slicing the stokehold in a coal-fired steamer. It took three days to get this picture, stripped to the waist in the intense heat, with dust and sweat clogging my eyes.*

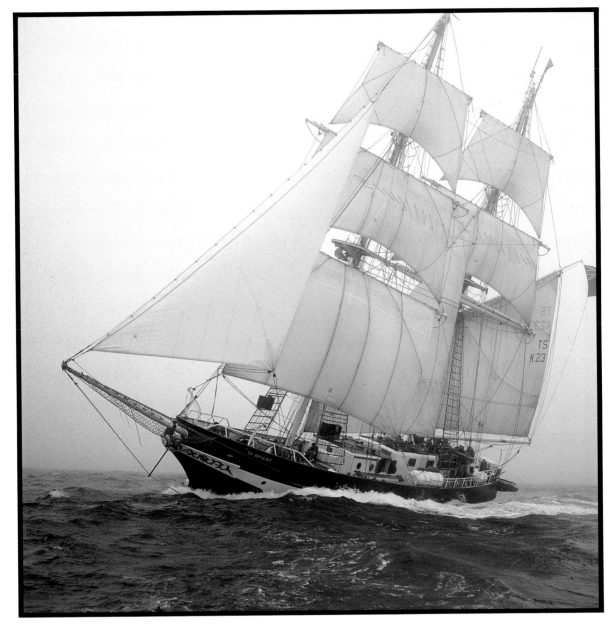

13. *Lumpy sea and miserable Channel weather as the brig* Royalist *heads for Spain. Monochromatic colours with a touch of red.*

14. *Chagall? Just reflections in Stockholm Harbour. Medium telephoto,
slow shutter speed.*

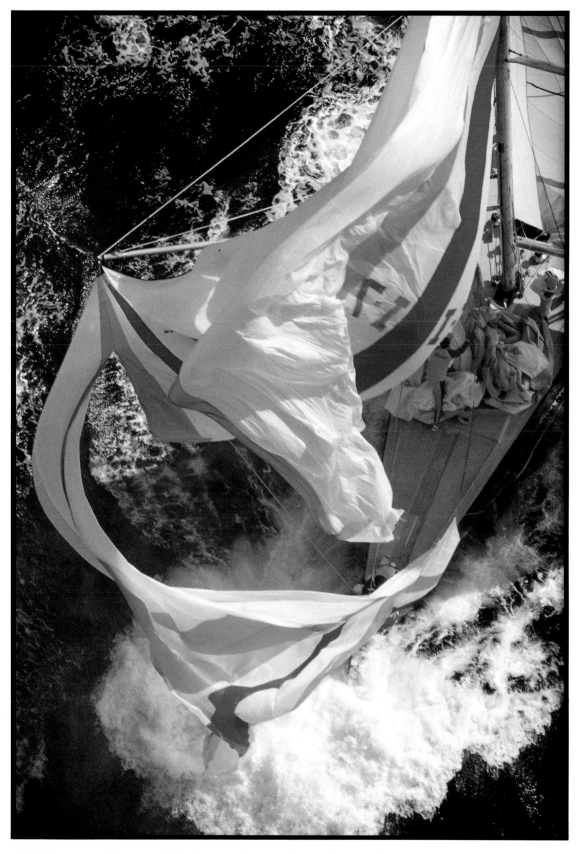

15. *When staying alert pays off. In this case there was also an element of luck in being close by and having a highly skilled pilot at the helicopter controls.*

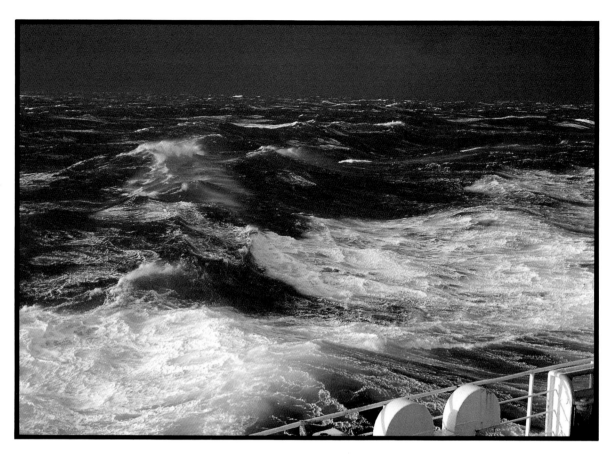

16. More often than not, telephoto lenses are used to compress waves. But the much maligned 50 mm standard lens can produce dramatic results, given the right circumstances.

17. Seagull, taken with a 300 mm lens from the deck of a ship, slow shutter speed.

18. *All taken with a Polaroid 680 autofocus camera and instant print film producing a unique effect. Autographs were added by each sitter as the print developed.* (Left to right) *Peter Blake, skipper of* Steinlager II; *Tracy Edwards, skipper of* Maiden; *the late Tom Blackaller after winning the Fastnet Race; and Norway's Peter Lunde.*

19. Regatta fireworks: a long time exposure (more than 20 minutes) was needed to capture the overall effect of a torchlight procession at Bursledon.

20. Old boatyards never die. Peaceful winter morning on the Hamble River.

The *tug-boat* also has a displacement-type hull but this is squashed up to produce something akin to a fat porker. Since the middle of the ship sits low in the water it appears to be sucked down by its own power and weight, and the ends have to be very buoyant to prevent it from sinking when under way. A great frothing wall of water at the bow and hooked-up wash at the stern is indicative of the power of these little ships.

Armed with this extra knowledge, and by employing sound photographic techniques, the photographer can now attempt a graphic interpretation of the type and purpose of each vessel. Use your lenses to help achieve the right effect.

USING LENSES

Longer lenses compress spacial perspective and graphically improve scale. As a general rule, the larger and more powerful the subject, the more it will benefit from special treatment using longer-than-normal focal-length optics. *Wide-angle lenses* diminish these effects but are essential for close-distance work when an expansive view is required. The longer focal length produces a more natural perspective and such is the nature of the subject and the distances from which the photographer is often forced to work, that the telephoto lens in varying focal lengths becomes the standard tool for a lot of work. (See also Chapters 1 and 5)

Aside from the problems of camera-to-subject distance, which the photographer is likely to encounter whether working from the shoreline or from shipboard, the medium telephoto lens of between 100 mm and 200 mm is useful for shooting pure record material where it might be an advantage to show off some particular design aspect of the craft in question. The milder effect of compression using prime lenses or a zoom in this range is usually just enough to accurately convey the aesthetic qualities of a pronounced sheer, topside shapes and deck camber, all of which could be of interest to the builder and designer. When a more dramatic effect is required for purely pictorial reasons, choose lenses of 180 mm or more. Subjects at a great distance will not look unduly distorted, if at all; but yachts and ships which are closer to the camera will present fewer angles from which they can be photographed well. In this case, longer lenses are used to pick out areas of activity and detail which the photographer sees as a basis for more artistic and dramatic works.

Longer lenses are especially useful when the photographer is attempting to pull a scene together. The start of a yacht or powerboat race often appears dramatic to the casual onlooker because of the apparently large

number of contestants spread over a wide area. The mind is able to encompass the whole scene by looking at various parts of it and assembling the parts as a whole. The camera cannot perform such subjective assimilations and needs quite a lot of help from the user to produce a satisfactory image of the events.

The ability of long lenses to compress the spatial distance which exists in reality gives the creative photographer plenty of opportunity to take part of a fairly dispersed event and compress the essential ingredients into a small area so that the resulting picture, although somewhat distorted, actually gives a more realistic view of what might have been happening.

WEATHER

Afloat, one is often more aware of changing weather conditions than when onshore. The vast expanses of water, horizon and sky act as a screen onto which patterns of clouds, sun, sea state and strength of wind are projected. A knowledge of these elements can be used as a basic weather forecasting system.

Cumulus As the ground temperature rises, clouds known as fair-weather cumuli ('cotton wool-type') rise and form huge, towering *cumulo nimbus* ('nimbus' being the Latin for rain). Sometimes, these clouds grow into huge monsters, having an anvil shape at the top which is formed almost entirely of ice crystals. The base of the cloud is usually full of water and indicative of a forthcoming shower or heavy rainstorm in milder seasons, and sleet or snow, or both, in colder periods.

Stratus This is a general term for layer- or blanket-type clouds. *Cirro stratus* is a high-level layer of cloud formed almost entirely of ice crystals which sometimes gives a halo effect when the sun shines through it. The presence of these clouds is often indicative of quickly changing weather patterns and the onset of rain or showers. *Alto stratus*, a lower level of cloud base, also indicates that rain is likely within a few hours of this pattern passing overhead. It is the type of cloud formation which photographers often associate with brilliant sky colours during early morning or late evening.

Fracto This is found in two forms: *fracto nimbus* or *fracto stratus*. The latter is a low-altitude cloud, dark grey in tone and often seen scudding quickly across the skyline. It is sometimes called 'scud' for just that reason. This type of cloud often precedes cold-front *cumulo nimbus*, clouds which are smaller than their anvil-shaped relatives, and which indicate a line of storms or heavy rain which may be visible travelling a few kilometres

behind the cloud formation. Once the rain has passed, a corridor of much cooler, cloudless air passes until the next front is preceded by another line of cloud and, possibly, another rain storm. These patterns can take several hours to pass overhead. They can be seen after the centre of a depression has passed through and are generally indicative of another depression to follow in a few hours.

Weather maps showing the barometric pressure of highs and lows and the spacing of isobars which can be used as an indicator of wind strengths are published daily by a number of national newspapers; they can be used to give a rough guide to what the weather is likely to do in the succeeding 24 hours. Most local meteorological departments have access to recent satellite pictures which show rain patterns and cloud formations and, if you are planning a really important assignment that has to be tied down to a certain time, an input into the planning from as many sources as possible is essential when more than an element of luck is needed for a successful shoot.

PLANNING

In my experience most successful pictures have been produced as a result of a combination of ground work – which has sometimes taken days and involved numerous telephone calls, visits to a location and film tests to make sure that nothing could go wrong when the real time came – and all the planned elements coming together pretty much at the right time.

Sourcing picture ideas is not difficult; indeed it should be one of the most interesting aspects of the enthusiast's work. Picture opportunities present themselves in a number of ways: personal contact with someone who knows when an event is about to take place, ideas that simply come into one's head, stories in newspapers, magazines, on television or the radio and so on. However, the saying 'Ships and tide wait for no man' is particularly apt in this activity. Conversely, the other side of this coin is also true: ships are often late – both departing and arriving. Always allow plenty of time before a departure. This and any other waiting time can usefully be used in shooting the unexpected extra picture.

Here are two examples of how some advance planning helped me to shoot pictures I feel could not easily be repeated.

I had read in a local newspaper that the North Atlantic passenger liner SS *France* would make one last visit to Southampton before being withdrawn from service and 'mothballed'. I wanted something different, a picture that would show the majesty of this elegant ship under way,

instead of the normal 'docking' routine for which everyone gathered on the end of the pier. Apart from an aerial portrait which would have been easy enough to arrange, I could not think of much that was inspiring until I noticed that a local yacht club was staging a race to start close to the beach where I lived. From a cursory study of the chart for the area it was obvious that the *France* would pass on a course opposing that of the yachts, in the deep-water channel on the Isle of Wight side of the Solent. The distance between the ship and the beach was several miles, but with the right lens, there was a chance I could obtain a picture similar to the one I had sketched out with a pencil. (Sketching is a technique I often use to clarify some ideas; an *aide-mémoire*, which does not have to be adhered to rigidly but is useful in formulating ideas from which the main and secondary pictures may evolve.) I made a note of the time of the start of the yacht race, checked the time of high water and rang the port control officer at Southampton to find out the estimated time of arrival of the *France*. There was almost half an hour's difference at the point which I had chosen on the chart for the cross, so my idea was beginning to look like a dead duck from the start. But I knew from experience that not all ships run to time.

When the day came, I made my way down to the yacht club on the beach and hung about on the verandah watching the yachts ready themselves for the long night race that would soon start. It was late afternoon, the light was failing westward, casting long shadows from the masts across the sea. If nothing else, I might go home with a pleasant little yacht race picture.

As the minutes ticked by to the first preparatory cannon signal, I began to scan the horizon, thinking that if the ship didn't show within the next minute or so, I might as well relax and head for the bar. As I was thinking this, the sun caught the glint of white upperworks and soon the huge black hull of 60,000 tons of steel could be seen thundering towards the deep-water channel. The rest is history. The ship was travelling so fast that I thought at one stage the yachts would be too late starting their race. But 'lady luck' and a 600 mm lens combined to give me the one frame I wanted. The picture of the SS *France* illustrates well the opportunities for the photographer who, for various reasons, is land bound (see plate 34 on pages 110–11).

In the second example, taken afloat, a similar picture could perhaps have been shot from the shoreline, although it would have required a much longer lens than the 400 mm I was using at the time and the crowds lining the foreshore would almost certainly have hindered a photographer's chances. In lots of ways, this picture also marked a turning point in my overall conception of how racing yachts ought to be photographed.

Instead of the stereotyped yacht portraits which had been in vogue since the birth of marine photography, I wanted a shot which captured an element of competition. The starting line, which frequently brings together large numbers of boats, seemed the place to be.

The planning for this picture centred around a light-hearted discussion between my launch driver and myself on the morning of the race. It was to be one of several important races in the bi-annual Admiral's Cup event, an international regatta bringing together three boat teams from up to 17 nations at Cowes. No quarter is spared by the skippers and crews of these ocean racers, either between themselves or toward the spectators afloat, or other yachts which may be unfortunate enough to find themselves in the same area when a race is about to begin.

The day before the race, my skipper and I had decided to take a large 70 ft launch as the photo platform. The weather forecast indicated a miserable day ahead; the water in some parts of the Solent would be fairly lumpy. As I was planning to use my longer lenses, I wanted a stable platform. However, just before leaving our mooring, we shipped a smaller outboard powered launch onto the after-deck, intending to use it to reach the town quay should we leave the mother ship at anchor off Cowes.

On the way to Cowes it became obvious that the weather was deteriorating rapidly, a good blow coming in from the south-west. The start to the west would be on the Royal Yacht Squadron line and with the wind strength as it was, we could expect a dramatic start to the day. I knew the picture I wanted could not be had from the big launch as our size would have been considered inconvenient by other members of the yachting fraternity and there were some ugly rocks close inshore.

We found an anchorage off the East Cowes breakwater and proceeded to rig the launch with a heavy tarpaulin to keep out some of the sea water that we were obviously going to encounter in the choppy seas. Keeping equipment and film dry would be a major problem, so as well the boat cover, we took an array of foam cushions and oilskin coats which were laid out under the cover. As soon as the preparatory gun had been fired from the squadron, we lowered our chariot into the sea and cast off, threading our way quietly through the rows of anchored boats towards the squadron end of the start line. I knew if we arrived there too early, in a flurry of spray, our bright orange craft would be thrown out of the area by the course marshalls.

The picture I wanted would begin to happen seconds before the start gun was fired. At this time, under these weather conditions and with this many yachts there would be pandemonium on the line. Our own position would be vulnerable so I was relying on my skipper to know exactly what

I wanted and when it was likely to happen. We hung about well out of the start-line area for as long as possible, watched the marshalls race off to the outer end of the line and then stormed in to take up our position a few hundred metres off the Squadron. If anyone had shouted for us to clear out we would never have heard, such was the noise coming from the yachts now heading straight for our launch at an alarming rate. My helmsman concentrated on keeping the launch on station in an area of lumpy, turbulent water; my efforts were directed through the end of a 400 mm Novoflex, praying that when the moment came to squeeze the button, nothing would get in the way. Only one frame would count; the yachts were coming down fast and the frame was filling quickly with a confused array of masts, sails, bodies and spray.

Later that day after I had hung the film up to dry, I found that three frames out of four were sharp, but there was only one picture. It has so far stood the test of time; subsequent efforts to repeat the same picture have come nowhere near as close to conveying the sense of urgency or drama.

Although the planning for this picture was a lot less coherent than for the first example, its success or failure relying largely on constantly moving parameters, both I and my helmsman knew exactly what was required, when it could be shot and how to adjust to the situation as it developed in front of us. Without the knowledge of what is going on on a course, the chances of success become fairly slim.

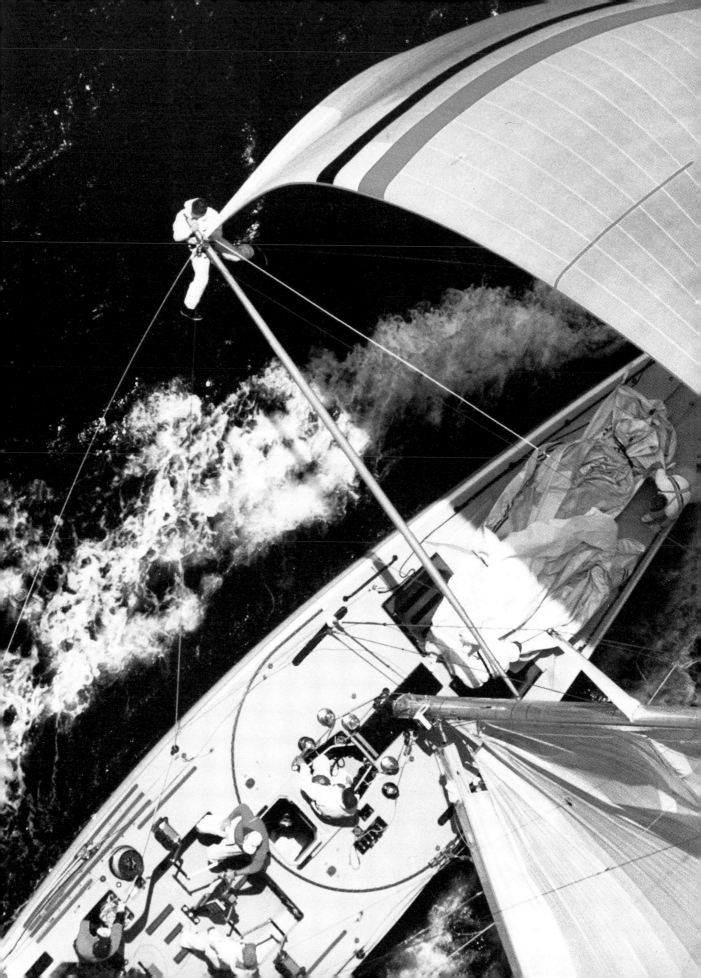

16. *Patience is as much a part of the photographer's equipment as the hardware. On the island of Sandhamn, Sweden. 200 mm lens.*

15. (PREVIOUS PAGE) *Overhead photography from helicopters should observe height restrictions required by common sense and the organisers' rules. This picture was made from over 700 ft with a Novoflex 600 mm lens.*

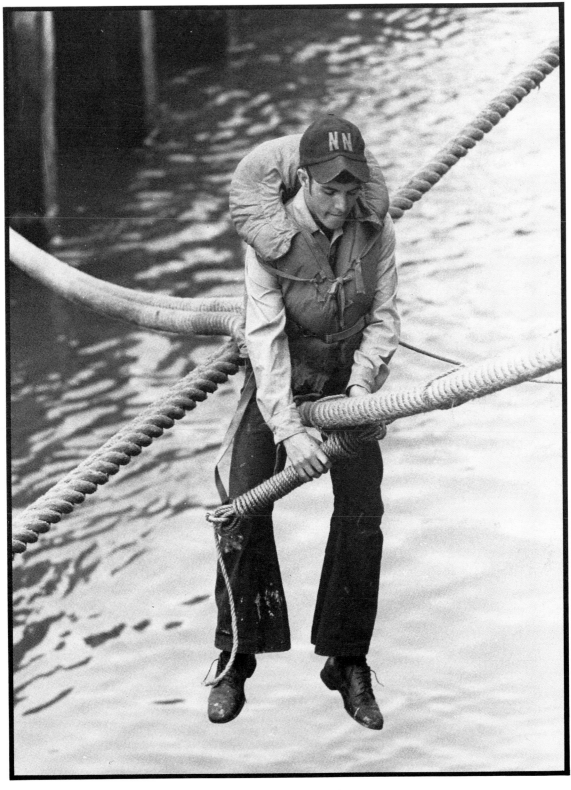

17. *Frapping warps on the USS* Newport News. *This would not have worked as well shot from the quay.*

*18. A dramatic interpretation of barge hatches on the Seine near Paris.
35 mm SLR, 300 mm lens.*

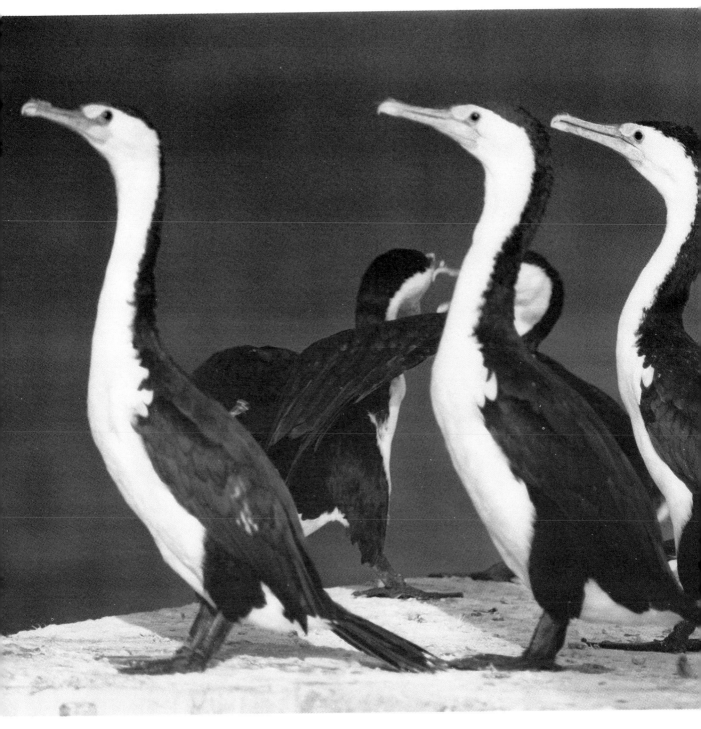

19. *The Novoflex system makes hand-held shooting with telephoto lenses a simple pleasure. Cormorants in Australia with 600 mm f/8.*

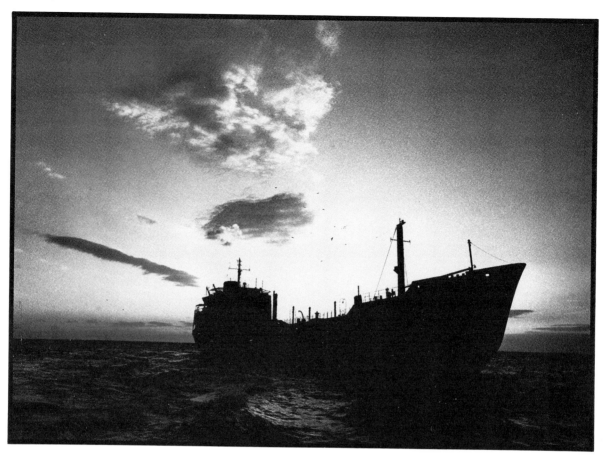

20. *Freighter off the Needles at dusk, from a story on Trinity House pilots. An orange filter helps to darken sky and water. 35 mm SLR, 28 mm lens.*

4

SCOPE

For the professional, there are times when coverage of a particular yachting event can mean travelling half way or even all the way around the world in search of pictures. But there is no guarantee that the pictures you come home with will be any better or any more in demand than those you could have taken on the home stamping ground.

Perhaps a third of my material has been shot without the need for a floating platform. In some cases, the better picture has originated from a shore-based position and there have been many occasions when I have photographed small boats and large ships with ease from high buildings or bridges. The fact that many of these pictures have been used by newspapers and magazines in preference to others shot from floating platforms is sufficient proof, if any were needed, to show the beginner that the most expensive tool apart from camera hardware, is likely to be a good pair of walking boots!

Yacht racing is just one subject area, however; quiet backwaters can often produce pictures of interest as well as ideas for picture stories, features and the chance to meet people who are not normally associated with the frenzy of winning races. If you are interested in portraiture, you may well find a whole new panorama of photogenic sailors, fishermen and yachtsmen willing to stand or sit in front of your camera.

The creeks and harbours, the old boatyards and marinas, boatsheds and factories, slipways and drydocks, wharfs and pontoons, all provide an unending supply of material for the observant photographer. Neither is the scope of the subject restricted to any one season of the year which in yachting terms have been traditionally divided into three periods: autumn through winter (laying up); spring to Whitsun (fitting out); and summer to autumn (sailing). Many yachtsmen still adhere to this calendar, give or take a few weeks. Much is dependent on prevailing weather, long-term forecasts and the functions organised by yacht clubs to which they may belong. But on the whole, a lot more people now manage to stay afloat and sail for longer periods than they ever did before, thanks to the huge reduction in maintenance tasks brought about by plastics technology in boatbuilding.

The considerable increase in boat ownership per head of population in the last few decades also means that there tends to be greater activity onshore and afloat in the boating world; theoretically, at least, there is no time in the year when the photographer can say there is nothing to shoot.

THE SEA

People may provide scale and animation, but the sea and its secrets provide a different sort of attraction. Just as the way boats plunge and roll across and through the waves is related to their shape and the state of the sea, so the sea's movements depend on the prevailing weather conditions. Some study of waves is helpful to see how and when they crash and if there is any truth in the legend that every seventh wave is larger than the preceding six.

Storms and tempests provide the kind of dramatic stage scenes which have a life of their own, being, without doubt, one of the most difficult of nature's phenomena to photograph well. It may not be pleasant to huddle on a rocky shore in the heart of winter trying to capture the seething power of raw sea, but it is certainly exhilarating!

The 'lee' shore, of course, is the one that sailors fear most, especially when they are caught in its shadow. It is an awkward place, too, for the photographer, though nothing like as dangerous unless too close to a precipitous cliff. Working off a beach during a gale is not easy. A good force 8 blowing straight up the beach or over the top of a cliff is more than likely to knock the unprepared photographer off his or her feet. If you know of a good location from which to shoot and which is easily accessible it will pay to scout a vantage point well in advance of a shoot planned for bad weather. The equipment used will depend largely on the type of picture required, but I nearly always shoot dramatic seas with a medium- to long-focal-length lens. In a mean, gusting wind, the longer the lens, the more difficult it is to hold steady.

A tripod is often too restricting but if it is heavy and solid and its feet can be spiked into the soil or sand, it will make as good a platform as you are likely to get when using the longer lenses. When I am doing this sort of stake-out, I try to find a vantage point that will give me a little shelter: a sand dune, a rock, the side of a beach hut. By contorting myself into a ball or some other acrobatic position I try to wedge the camera lens against a limb, the rock or any other available object. The longer the lens, the more compressive the effect and the narrower the angle of view, which is a small advantage over the wider lens because there is no need to 'hunt' the lens across acres of ocean to see a different picture unfolding.

There are other considerations to be aware of when working in these circumstances, all of which are seemingly sent to plague the photographer: flying sand, stinging salt spray (which, if it is combined with rain, may do less harm than you think) and biting cold. Equinoctial gales tend to come in the middle of September through early October, although they have been known to come later. Late December through March are also excellently served by bad weather. The photographer must be well protected at all times and should be aware of the fact that it takes a matter of only minutes of exposure to the worst conditions before a general freeze begins to numb the body. In winter, quilted thermal suits should be *de rigueur* under any outer clothing worn under a protective all-weather suit. Fingerless woollen gloves are useful worn inside quilted mittens of the type used for skiing.

Equipment protection has already been discussed (see pages 37–42). Remember that if you are using a camera with a changeable film back such as the Hasselblad, great care should be taken to keep loaded and exposed magazines well protected from flying sand when switching from one to the other. Under the type of conditions described, in the event of a failure, there will be little alternative but to pack up and return to base.

With larger-format equipment, which invariably has to be tripod mounted, more attention to protecting the camera may be required; rolls of 'gaffer tape' are always useful, so keep at least one and plenty of plastic shopping bags to hand. A clean chamois leather is essential for wiping salt spray from all lenses which can then be protected with the palm of the hand until just before the exposure is made.

Lighting conditions vary, of course, but sidelighting or backlighting is ideal because it adds depth to a picture. Gales frequently coincide with high tides, the high point of a storm often occurring during the night. By dawn the storm may well have blown itself out and moved on to another location; but a gale can blow for eight hours or more giving the knowledgeable photographer plenty of opportunity to reach a particular location and get to work. Late afternoon and early mornings, when the sun is low in the sky, provide the best light.

The calm after the storm also provides many opportunities for good pictures of rollers breaking on the beach. In locations where the beach forms a shallow run out to sea, the breakers may not be very large unless a big sea has been running further out for some days. Where the beach shelves in a steep dive, each high tide will bring bigger rollers crashing onto the beach and if this is combined with an already big sea, some of the waves will be monsters. Again, sidelighting or backlighting help to improve the picture, adding depth, modelling and translucency to the water.

Do not be afraid to experiment with slow shutter speeds and long lenses or zooming through a half-second exposure.

The zooming technique is fairly simple and works best with colour emulsions. Select a fairly slow ISO speed film such as Fujichrome 50 or Kodachrome 25. Use a slow shutter speed of less than $\frac{1}{8}$ second, say half a second, and adjust the aperture for the correct exposure. Focus the lens at its full extension (telephoto or wide) and frame the part of the subject you wish to shoot. When ready, squeeze the shutter gently and zoom outward (or inward) through the exposure. The trick is to keep the camera and lens rock steady through the exposure. Stabbing at the shutter release and operating the zoom in a jerky manner will spoil the overall effect. Faster shutter speeds can be used as well, but some practice is usually needed which will result in a lot of wasted film. Try using the technique with the camera empty.

WORKING ALOFT

A high vantage point can often work to the photographer's advantage: what sometimes appears to be a mundane subject from a ground position can be transformed when viewed from higher up. On the other hand, this does not always mean that a mobile platform such as an aircraft or helicopter has to be used.

The higher vantage point can nearly always be found around a boatyard. Even something as lowly as a ladder can give the photographer a new perspective on the subject. A ladder firmly held at its base by people who have the photographer's interests at heart, can be walked up with very little difficulty. Small, folding stepladders can be purchased from virtually any hardware store. I keep a set in the boot of my car and they have more than paid their way in helping to produce pictures that I might otherwise have left until another time, or worse, not shot at all.

Buildings, rooftops, crane jibs and fire escapes are all suitable platforms from which to take a picture, but in many cases permission to climb them will have to be sought. Even then, you may find that permission cannot be granted unless you are prepared to sign what is known as a 'blood chit', a form releasing the owner of all responsibility in the event of an ensuing accident. Generally, I have found managers and owners more than willing to oblige their rooftops or upper-storey windows; if the location is a good one and you plan to use it often, a few prints handed to the person responsible will help smooth the path.

Access to buildings in larger ports and on Ministry of Defence property, such as in a naval dockyard, will have to be sought through the proper

channels. A letter or telephone call to the public relations department explaining your requirement as concisely as possible and the reason for it, is the usual protocol.

AIRBORNE

The world of ships and boating takes on quite a different dimension from the air. For fast-moving subjects such as offshore powerboats, the helicopter is an ideal platform. Formula one racing machines can travel across the water at speeds in excess of a 100 km per hour; in a lumpy sea, they tend to spend almost as much time flying as the airborne photographer. Helicopters are far more manoeuvrable than light planes which nearly always have to fly at almost stalling speed when trying to keep close station on the craft below. A helicopter with a good pilot can dance rings around a powerboat, placing the photographer exactly where he or she wants to be.

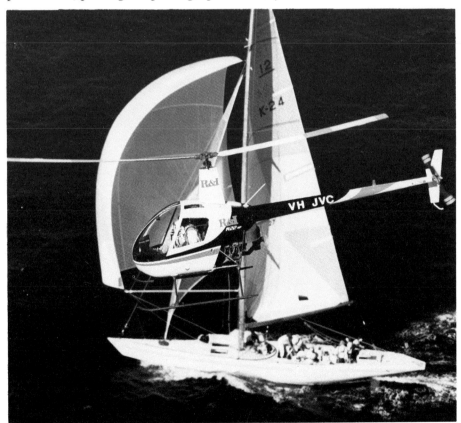

Airborne photography of yachts requires precise teamwork from pilot and photographer and strict observance of race organisers' requests to keep well clear of competing boats.

73

The slight edge that a fixed-wing plane has over a helicopter has to do with vibration. There is always a lot less in the light plane. Vibration in a helicopter varies from one type to another depending on the type of engine, number of revolutions per minute and size of the rotor blades. Small planes such as the tiny two-seater Robinson are almost vibration-free. The single-engined turbine-driven Bell Jet Ranger vibrates more under certain weather conditions than its bigger, twin-engined brother. Older types with rotary piston engines seem to shake, rattle and roll their way around the sky, but the vibration frequency is often slower than in more modern craft, making it easier for the photographer.

As always, part of the key to success relies on an effective rapport existing between photographer and pilot. But the photographer must know what is required of an airborne shoot and know how to pass on the information to the pilot in a clear and comprehensive manner. Understanding the flying limits of the aircraft and having a sound knowledge of how those limits will affect photography and what can and cannot be done with the plane when particular situations develop are both essential.

First-timers should take the trouble to turn up at the pick-up location in plenty of time so they can discuss the assignment and its requirements with the pilot. A pilot will know whether you have flown before and how experienced you are simply by the way you react on the ground around the aircraft and what you do or do not do when trying to settle in. Never adopt the 'worn that T-shirt, seen that movie' attitude. Use the opportunity to let the pilot know you want to learn about his job; most live as much for flying as you do for photography and will be only too happy to talk about their profession.

Occasionally, you may run into a pilot who has never done any aerial photography before. He or she will be as anxious to know what you want as you are anxious to obtain it. Explain what you want in as much detail as possible; the pilot will soon tell you whether or not it is possible and will suggest alternatives in the latter case.

Powerboats are relatively easy to capture on film from the air. Sailing is a different ball game and has a totally different set of rules for airborne photographers. First you need to know at least the basics of sailing in a yacht race, what happens on a short course where the yachts are sailing around marker buoys, what will happen if your aircraft overflies yachts reaching or running under spinnaker and hovers too low. The pilot should know these things too, or at least be made aware of the fact that his rotor blades are liable to cause a hefty downwash of air that could collapse a spinnaker, stop a sail boat dead in its tracks and do other unthinkable damage. Flying too low is liable to make you a lot of enemies on the ocean

very quickly. With the sophisticated equipment available to photographers today, there is no reason at all to be flying at less than 300 feet (100 m) over racing yachts. Unnecessary harassment will bring retribution in one form or another from the race organisers and possibly even from the governing body of the sport, which ultimately prevents everyone from doing their job in a satisfactory manner. Fortunately, most pilots are more aware than some photographers of where they should be in the sky in relation to the yachts below. Air-traffic control will specify and possibly even impose certain height restrictions for overflying yacht races, having already received requests to do so from race organisers. Pilots who value their licences much more than they are ever likely to value a photograph, will stick rigidly to the rules. Those who are prepared to bend the rules slightly will invariably only do so if they are confident that the photographer knows what is happening on the ocean and understands any difficulties the pilot is likely to run into. All this is fine provided, of course, photographer and pilot can communicate in a language that both understand. Difficulties can arise when flying in a foreign country. Although the language of the air is said to be English, it is surprising how quickly some foreign pilots can lose their command of the language when asked to do something they feel is either against the rules or just too downright dangerous!

Below is a list of basic 'ground rules' which the flying photographer should bear in mind. These may vary according to the country and/or climate and a good deal of common sense should prevail. Bear in mind that most photographers prefer to fly photographic assignments with at least one door off the aircraft. If there is more than one photographer, shooting arrangements will have to be shared in some smaller planes and you will have to sort this out on the ground before take-off with the pilot, who gives the final approval as to what part of his aircraft is removed for the flight.

Ground Rules for the Flying Photographer

1 *Protective clothing*: wear a one-piece weatherproof overall over reasonable thicknesses of clothing. A hot summer's day in England may seem one thing when at ground level; in the air, hanging out of an open door when charging along at close to 150 knots, it is quite another. Rubber wading boots and thick socks are essential. Wear a life-jacket under the one-piece suit or use a suit with a built-in life preserver.

2 Take one bag containing only the essentials for the assignment. *Never* take overloaded gadget bags or aluminium boxes. Work out before the flight exactly what you are likely to need in the way of lenses and

bodies. The bag should preferably be of the soft type that can sit on the cabin floor and which has easy access.

3 Do not take film in cardboard boxes or unopened packets. Ditch all extraneous rubbish before take-off. In flight, the space where the door had been removed will cause air to swirl around inside the cabin, picking up anything that isn't bolted down. The last thing the pilot wants is a lot of little cardboard boxes jamming his controls! Unpack the film and load plastic containers of unexposed film into one pocket of your overall. Exposed film, when unloaded, is slipped into an opposite pocket. Both pockets should be sealed with zippers or Velcro tabs. Empty containers are placed in the gadget bag which has one end of its flap open for access during the flight.

4 Pre-load all camera bodies and film magazines with film before the flight begins. Fit lenses you are likely to use, leaving others within easy reach, caps off, in the bag. Big lenses may have to be secured on seats in some aircraft; usually a matter of running the seat safety belt through the lens-carrying strap.

5 Before take-off, make sure there is a harness long enough for you to move about the aircraft. Most commercial helicopters that are not normally used for photographic assignments only have passenger seat belts which are very restrictive. If you are chartering the aircraft, try to arrange well in advance that the company can provide a suitable harness for the job. I have a special length of rope with stainless steel clips bent on to each end which I take along on these occasions. One end is clipped onto my safety harness, the other around a seat stanchion or eye bolt let into the floor of the aircraft.

6 Try to ensure that you know in advance the course over which the yachts will sail. With last-minute wind shifts, this is not always possible but a phone call to race headquarters before take-off is always a good idea. Once you know the area, discuss it with the pilot before take-off so that he knows more or less where he has to go. (There is nothing worse than being halfway through the flight to a location and having the pilot suddenly inform you that he does not know where the course is and neither do you.)

7 Charter time usually begins from the moment the aircraft starts up. If you have booked the minimum time, say an hour, you will be hard-pressed to shoot all the material you need, even if travelling time to and from the location is only ten minutes each way. Try to plan your shooting time in detail so that you know where you have to go to for each shot. To do this effectively you will need to know the weather conditions and roughly how long it will take the yachts to reach the

first mark of the course. If you are after specific boats, trying to read the names of each one from the air is a pretty forlorn exercise. Find out in advance what the boat looks like, make a mental note of distinguishing features on the deck, such as colour or numbers painted on it. (The sail number is carried on the mainsail as well as on panels attached to the side rails of the yacht toward the stern.) You will need hawk's eyes to spot what you want quickly; do not rely on the pilot for help either. He will be too busy flying and looking out for other planes in the immediate vicinity. At the start of a long-distance race, it helps to have an assistant in the aircraft who is familiar with the yachts and who can act as a spotter.

8 If, as is often the case, more than one photographer is flying in the same aircraft, the group should agree amongst themselves before take-off who will communicate with the pilot and what the plan of action is to be. The spokesperson should be the one who knows most about yachting and who can communicate requests and information to the pilot effectively. (If two or three people are all screaming to go to different locations simultaneously, no one is likely to go anywhere.) It may not be possible to fit all requests into the charter time, but, quite often, people will want to do similar things and a plan can usually satisfy most individuals.

9 Remember that yachtsmen tend not to like helicopters, in spite of the publicity the resulting photographs give their sport. Apart from the real risk of downwash collapsing a sail or, worse, shredding it to pieces, the cacophony of engine noise and swirling rotor blades is a real nuisance to yacht skippers trying to give orders across the deck to other crew members. If you must go in close for a particular shot, get in and out as quickly as possible.

For some, flying assignments are an acquired taste. I have found that photographers either love or hate them. It is certainly a very different experience from working at ground level and first-timers should be warned that words are pretty useless in trying to describe the effect on the body when a helicopter starts ducking and diving over the ocean – a little like riding a rollercoaster that has mysteriously lost its rails! For those that like it, or grow to like it, it is a most exhilarating experience and one that cannot be had too often. There are risks, of course, but then that is part of a photographer's life. Fly safely.

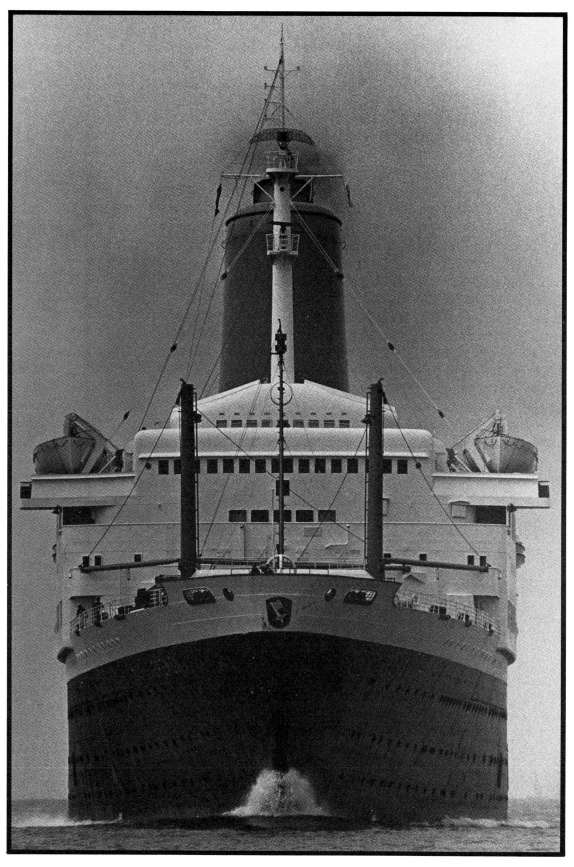

21. *The powerful end of one of the world's grand passenger liners, the scale of which is self evident. 35 mm SLR, 200 mm lens.*

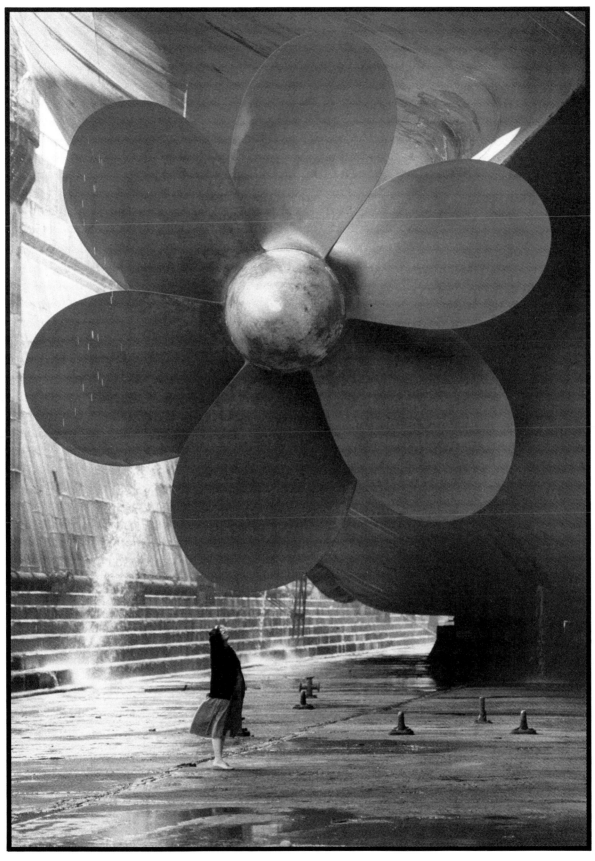

22. *In the confines of a dry dock, a 200 mm lens produces an arresting view of the QE2.*

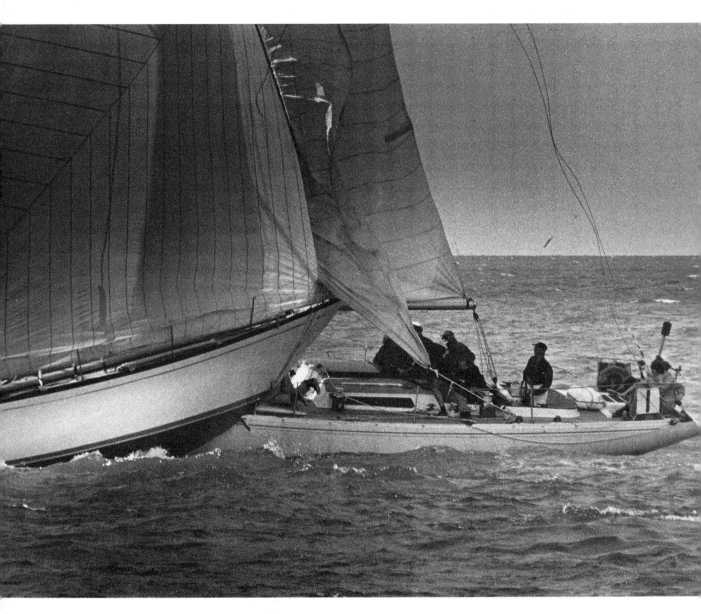

23. *This picture captures the ultimate start line collision –* Jan Pott *and* Griffin *off Cowes. 35 mm SLR, 300 mm lens.*

24. (RIGHT) Heart of America *has shredded one spinnaker, hoisted another, gybed, broken the spinnaker boom and lost a man overboard – see splash under spinnaker – all in a split second.*

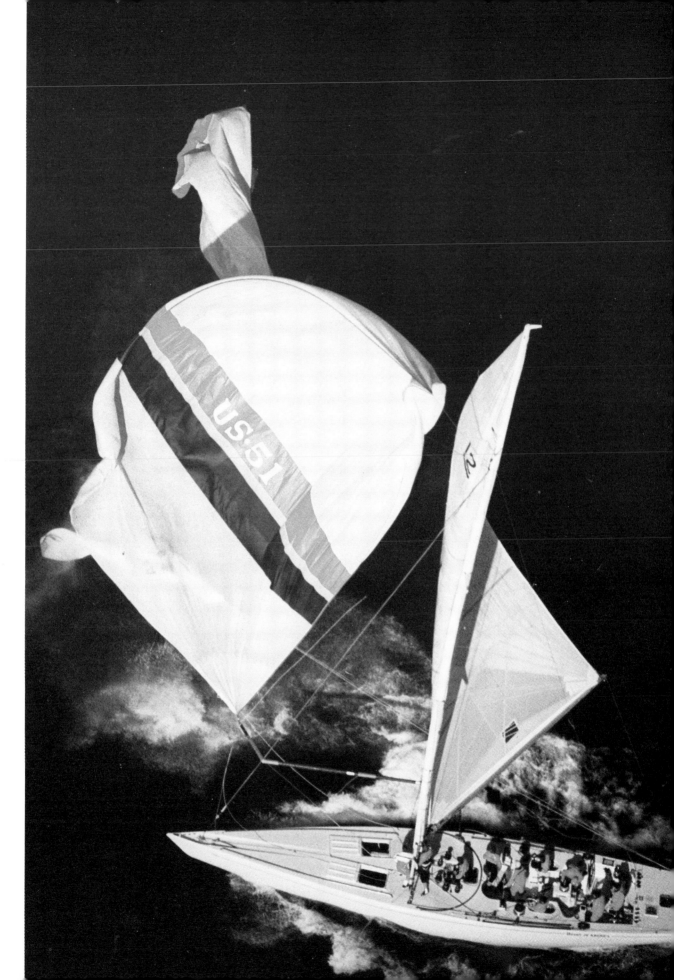

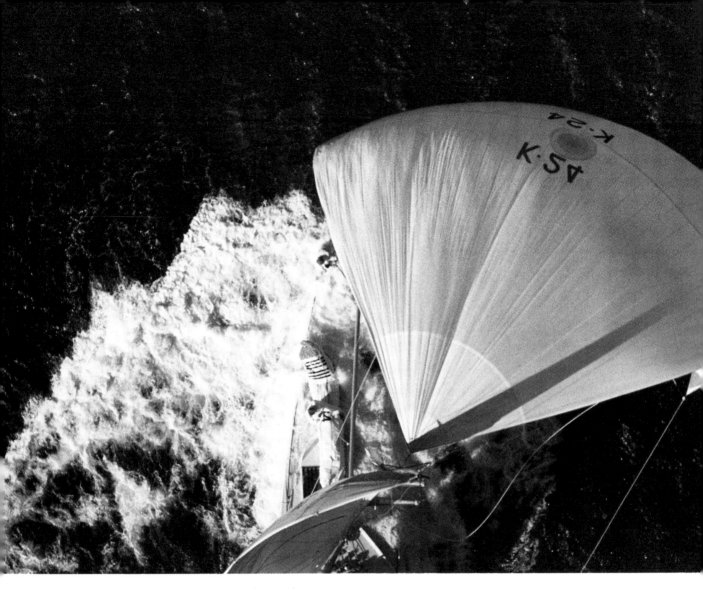

25. America's Cup: White Crusader *in heavy seas off Perth. Novoflex 600 mm, original in colour. (Courtesy of* The Associated Press.*)*

5

SEEING AS CAMERA

Good photography is all about recognising the photographic possibilities and, at the same time, establishing the purpose and function of a photograph before exposure. These functions can be split into three groups: the survey, the illustration and the picture.

The survey, the purest form of record, may be of use to students, historians, yacht designers and naval architects, designers of film or stage sets, artists, illustrators and mechanical and electrical engineers. The photographer should be concerned above all with taking the best possible view or set of views that show the information required. In photographing vessels under construction, the subject will have to be recorded from several different positions, at least some of which should include the plan profile, the end-on and the overhead view. Details of construction will require accurate lighting and great depth of field over the whole zone of the subject. Small-format cameras are not always suitable for this type of work unless used with perspective correction lenses. Some constructions take place in extremely confined areas, making it virtually impossible to make accurate photographic surveys without some distortion being present in the final photograph. However, it is possible, if no other equipment is available, to produce an acceptable building record which can be used by a wide variety of researchers and sales staff.

The illustration is essentially a boat portrait and is concerned with presenting the subject in such a way that its emotive and aesthetic qualities are shown to their best advantage. It should make the viewer immediately conscious of the elegance, the beauty and/or the historical associations of the subject. By far the largest number of photographs taken of ships, yachts and small boats fall in this category. From the professional point of view, the market for this type of work is very wide: illustrations are frequently required by publishers and ship and small-boat owners. Various subtle heightening techniques may be used to improve the backdrop. This includes providing adequate clear space around the subject to isolate and make it obvious that the boat or ship is the central point of interest. The use of filters helps to improve tonal contrasts in black and white and to correct colour casts and balance in transparency materials. Photographs should not aspire toward creating a 'moody effect' which reduces the

importance of the subject. Remember, it is the subject which is of greatest interest to the viewer.

The picture is the result of careful and selective composition using the aesthetic values of the whole or a part of the subject and its surroundings. The subject is presented in such a way that its graphical interpretation will be the primary motivator for the viewer. The desired effect may be achieved using any number of devices or a combination of device and technique, by simply 'seeing' the subject in a manner which allows instant pictorial interpretation. The picture is not especially concerned with imparting useful information about the subject although it may do so indirectly and in part.

Without first establishing purpose and function it is very difficult to be entirely objective. The photographer's visual perception of the subject at any given moment will depend on many other influences, some of which may not even be directly related to the subject. Ordinary human emotions such as excitement, tension, boredom, exhilaration, impatience, anger, joy and so on, all play their part in influencing the photographer's intention. In attempting to cover a yacht race, for example, there could be many incidents that occur suddenly to change or define how a picture is conceived. Here is an example.

A yacht race in the Baltic in fairly calm sea and wind conditions was in danger of sending photographers to sleep. Having taken every illustration necessary at an earlier stage of the racing, the possibility of a little action in the absence of a good breeze now only seemed possible at the turning marks of the course. Positions were selected to provide the best 'front' view to enable photographers to shoot a line of yachts heading for the camera and follow through as they rounded the mark.

We watched for several hours at each mark as yachts proceeded in sedate fashion, their crews darting and diving about as various deck skippers barked instructions in a variety of languages. It is on an occasion such as this that photographers become desperate for a picture. This happens a lot in sailing and is an occupational hazard over which those involved have no control. Hours spent like this on the ocean are little short of a disaster and require great efforts of concentration if the photographer hopes to return to base with anything even remotely worthwhile.

On this occasion, I had adopted the fairly relaxed and almost horizontal position of my companions, most of whom had travelled a great distance from the Far East in order to observe how their teams performed against Europeans. Every time their boat came within sight there would be a little flurry of activity in the cockpit as cameras were primed with fresh rolls of film. I was having difficulty using up one roll, but my colleagues seemed to take a different view. When confrontation between two of these super

yachts seemed imminent I watched the antics of crews on deck as they lowered and hoisted sail. There was a lot more shouting than action, or so it seemed, but for a few seconds, there was one tiny crew member who appeared to have found a new use for the deck: as a trampoline. In hoisting the huge spinnaker as rapidly as possible, this lightweight sailor launched himself off the deck like a rocket, pulling down on the halyard with the deadweight of his body. Another crew stood by, yelling encouragement. The airborne crew made my picture of the day and obtained some useful coverage back in Japan when it was wired over the same night. It certainly wasn't a once-in-a-lifetime shot, but it illustrates how apparent inactivity on the course can be turned to useful advantage.

At the other end of the scale, where the weather is apparently bad (but ideal for sailing) the brain is affected by so many different images occurring in rapid succession that isolating the most dramatic incidents and transferring them to film becomes a severe test of photographic skill, knowledge and endurance.

To be able to do this well, I must first have a boat capable of withstanding the conditions and a helmsman on whom I can rely entirely for his knowledge of yacht racing, and who will not compromise our position or that of any competing yacht. A trusting relationship – which gives the photographer a distinct advantage when working under adverse conditions and allows virtually 100 per cent concentration on the subject without the need to keep one eye on the boat pilot – can only be formed over a period of years and after many assignments. Rapport alone is not enough. Photographer and helmsman must work together as a professional team, each understanding the other's limitations and depth of knowledge about the subject. The American Howard Chapnick observed 'The grand delusion of contemporary photo-journalism is that anyone can make great pictures.' Recognising the picture possibilities as they develop rapidly in front of the lens comes with experience and dedication. Some photographers call it instinct, but this is invariably the result of many years of practice, of constantly searching the horizon for the unusual angle, putting lenses to work instead of using them simply as objectives to magnify an image, of employing the techniques of composition, lighting, perspective and making imaginative use of mood, content and animation. These elements can be effectively employed individually or combined to achieve outstanding results – or rubbish only fit for the bin. The photographer must constantly seek out subjects worthy of photography and attempt to transform all or part of them into images worth keeping.

In judging whether what has been shot is any good or not the professional has some advantage over the enthusiast in that good work circulated to a

wide variety of clients is likely to receive its just rewards. The enthusiastic hobbyist is less fortunate. Aside from photographic club competitions, there is little apart from the comments of friends and relatives by which the individual can gauge whether work is outstanding or not. The enthusiast is also disadvantaged in more obvious ways. He or she will not have the same opportunities as the professional photographer whose livelihood depends on being in the thick of the action most of the time. The range of subject material is therefore more confined and likely to be more pedestrian. In many ways, it is more difficult to create great works out of apparently inanimate subjects than it is to be plonked in the middle of a high-powered yacht race; a challenge which the professional often has little time to meet.

VISUAL PERCEPTION

The human eye transmits an enormous amount of information to the mind, reacting swiftly to changes of direction and focus. The same ability to convert the muddle normally seen by the eye into an image suspended in a frame ('seeing with square eyes') is the photographer's most precious and most frequently used tool. (Two L-shaped pieces of black card in the proportions of the format you are using, about 2 feet (60 cm) in length, can be used by anyone who might have difficulty in seeing the subject without the aid of a camera.) Leaving out what is not essential in a picture is often the hardest part. Even when a view appears to be so all-encompassing, so magnificent, that it demands to be photographed in its entirety, the result frequently disappoints simply because the scale of the two-dimensional print cannot begin to mirror the image of the real thing. The mind sees images selectively, taking in the grand vista piece by piece, and assembling it as a whole, even if subjects on the periphery are muted and out of focus. The colour of the sky or sea, the smell of the air, even the feel of the atmosphere and sting of salt spray, affect how we see the photograph at the moment of exposure.

The camera, on the other hand, is a mechanical extension of the eye only. As such, it is entirely objective and uncompromising in how it sees. Any erroneous matter left in the picture will be faithfully recorded.

ANGLES AND LENSES

Seeing as camera involves an understanding of the characteristics of each lens, the limitations of angle of view, what effects particular constructions

of diaphragm or mirrors are likely to have on backgrounds and at what aperture they perform best.

The distortion of verticals, horizontal planes and curves which are frequently apparent in marine subjects taken with wide-angle lenses is difficult to correct. In using these lenses for yacht portraiture, there are certain angles and positions which the photographer should try to avoid shooting from at close quarters. Direct beam-on shots which allow the whole boat to fill the frame can only distort the shape of the hull and foreshorten the apparent height of the mast. The wider the angle of view, the greater the distortion, so a hull with plenty of roundness at its widest point will appear more like an orange than its designer intended. Wide-angle lenses are useful for close-up work where the photographer aims to become as intimate as possible with the subject – without actually being on board the vessel; where the actions of the crew are more important than aspects of a particular craft; and when the photographer is working on board and it is essential to use these lenses to show the immediate environment to advantage.

Medium-length telephoto lenses in the 65 mm to 135 mm ranges in 35 mm and 105 mm to 180 mm in the 6 × 6 cm formats respectively are more suited to boat portraiture. They render a more exact perspective and scale with little or no apparent distortion. Their use also allows the photographer to work at a sensible distance from the subject. Wider-aperture lenses also permit a more selective zone of focus by throwing the background out of focus.

The ability of long-focal-length lenses to compress spatial distances makes them very useful for marine photographers who need to produce tightly composed pictures full of action, or who want to make use of the variety of colours which exist on a fleet of yachts sailing under spinnaker. The longer the focal length, the easier it is for the photographer to pin-point local action on board yachts and small boats while excluding extraneous matter from the picture.

A wide variety of such lenses are available 'off the shelf'. Lenses with larger maximum apertures tend to be more expensive than their smaller-apertured counterparts, but some cheaper lenses in the latter category may actually give a better quality result by employing high-quality frontal elements but having fewer others to correct barrel or chromatic aberrations.

Some independently manufactured super-low-dispersion glass-elemented lenses, commonly designated as SP (super performance), LD (low dispersion), FD (fluorite) and APO (apochromatic), of the wide-aperture variety have been known to produce low-contrast images with

disturbing breakup of the out-of-focus areas into double images rather than pure out-of-focus masses. This effect is frequently noticeable when these lenses are used in the stopped-down mode or when used with tele-converters not designed to match specifically with the prime lens construction. As these lenses represent a heavy investment for the freelance photographer, it is best to spend time researching and testing different lenses before committing funds to a purchase. Japanese manufactured lenses tend, as a general rule, to produce work of softer contrast and warmer colours, while those manufactured in West Germany are known for their high contrast and cooler colour renditions. The table on page 19 lists some of the super-performance lenses currently available. Prices are not indicated as these change from time to time and vary widely from dealer to dealer and country to country.

Mirror, or catadioptric, lenses are usually restricted by the maximum aperture but are none the less used a lot by marine photographers because of their lighter weight and the unique effect created on out-of-focus areas; this manifests itself as a pattern of ringed 'doughnut' shapes and can be effective when used well. On other occasions the out-of-focus effect becomes a monotonous prediction which actually does little to enhance the overall image. The focal lengths available range from 350 mm to 1200 mm.

All telephoto lenses over 280 mm are difficult to hold and use from the deck of a bouncing boat. Obtaining sharp, well-composed images frequently requires a comparatively high throughput of film. In selecting equipment for use in this environment, the photographer should bear in mind how weather conditions affect the state of the sea. The smaller the photo platform and the worse the weather, the more unstable the platform is likely to be. Since the subject will also be bouncing around, the use of heavy, extra-long-focal-length lenses will become increasingly impractical. Lighter lenses with smaller maximum apertures are quite suitable for almost every type of film and ISO rating as well as for most general lighting conditions.

Ultra-Low Dispersion Glass and Fluorite Lenses
Nikon and Canon have been at the forefront of the development of particular optical glasses for use in special and telephoto lenses to meet the demands of sports and news photographers. In the past, the problem has been to produce lenses with insignificant spherical or chromatic aberrations, the latter causing 'soft' images where blue and red light rays are focused on slightly different planes.

Nikon, who make their own glass, developed lenses with Extra-Low Dispersion glass (designated ED after the focal-length indicator). Canon developed UD (for Ultra-Low Dispersion) and FL (Fluorite) lenses employing glass made from calcium fluorite. The glass used has the same effect as glass used in APO lenses, producing high-quality, ultra-sharp images. Both companies have extensive lens listings which are published in special system handbooks and are available from reputable dealers.

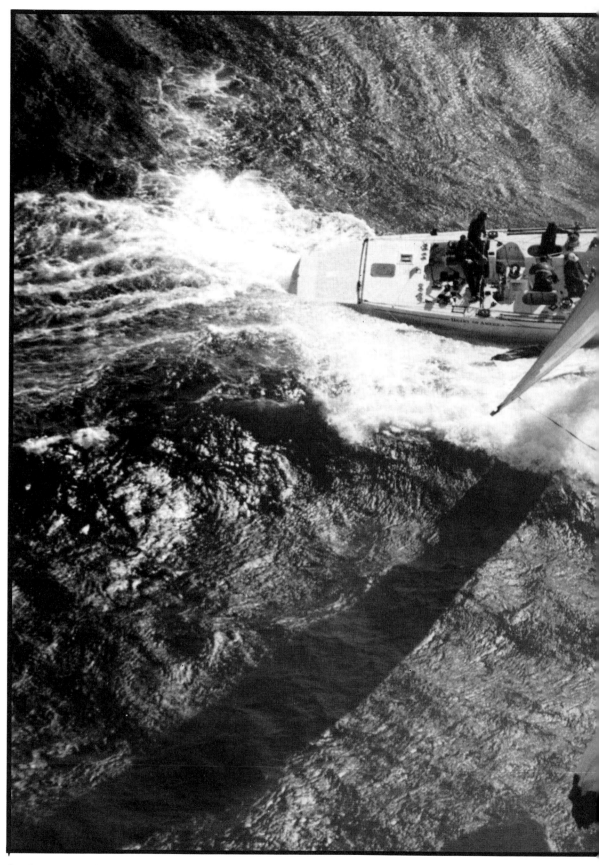

26. *Fine-grain colour negative materials such as Fujicolor 100 produce excellent prints, suitable for reproduction in black and white.*

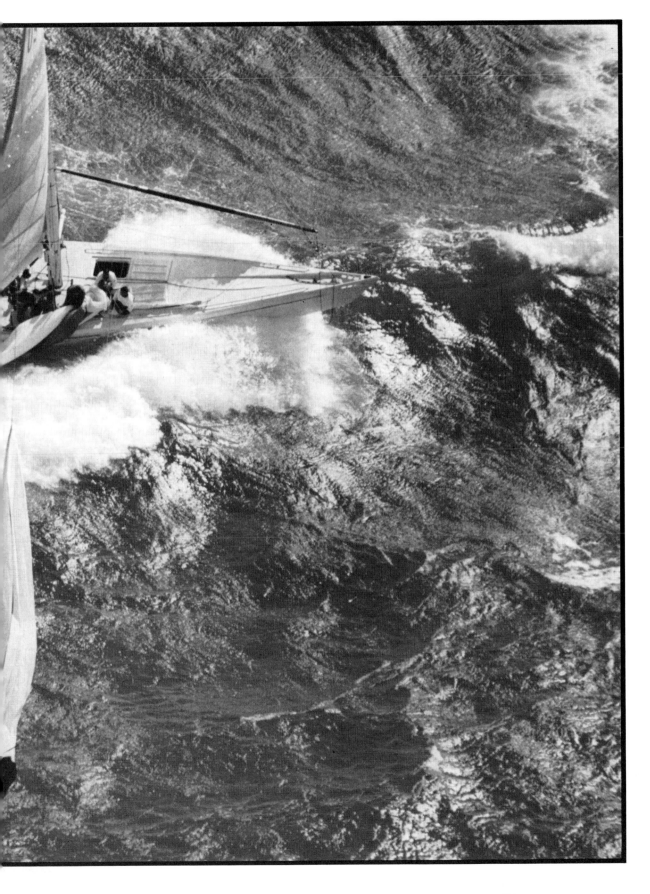

27. *Back lighting creates a simple but powerful design out of arrowhead and diagonal wave pattern.*

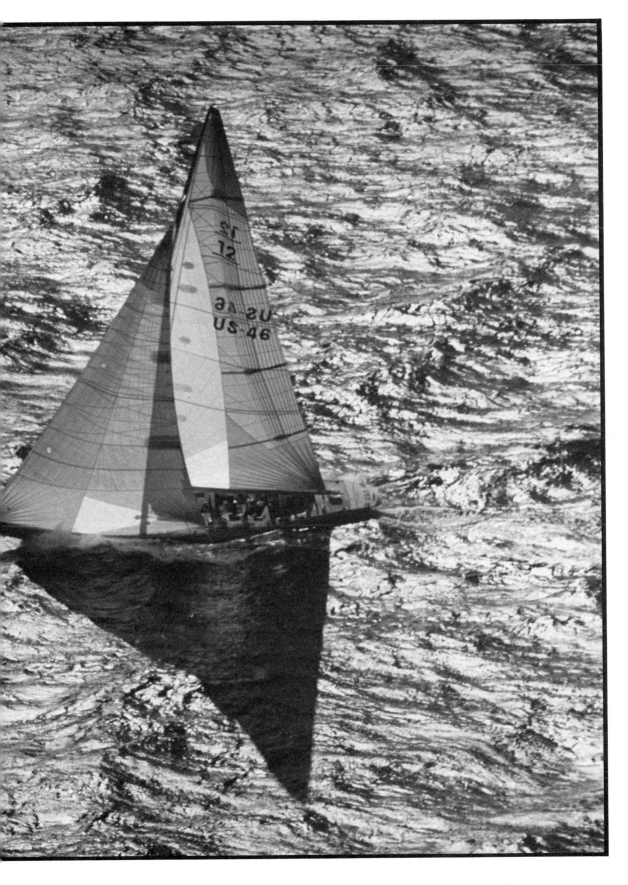

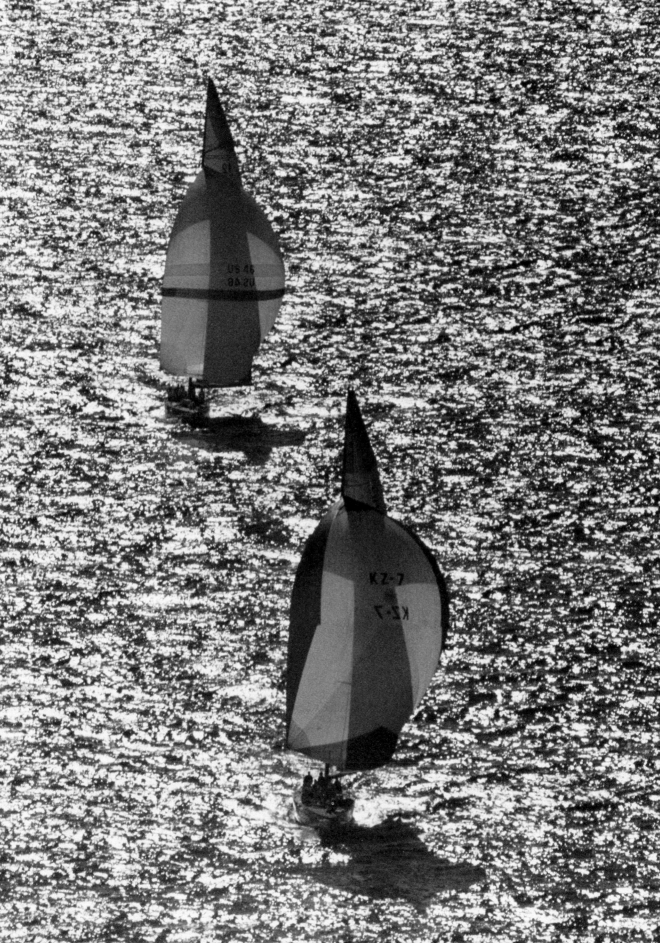

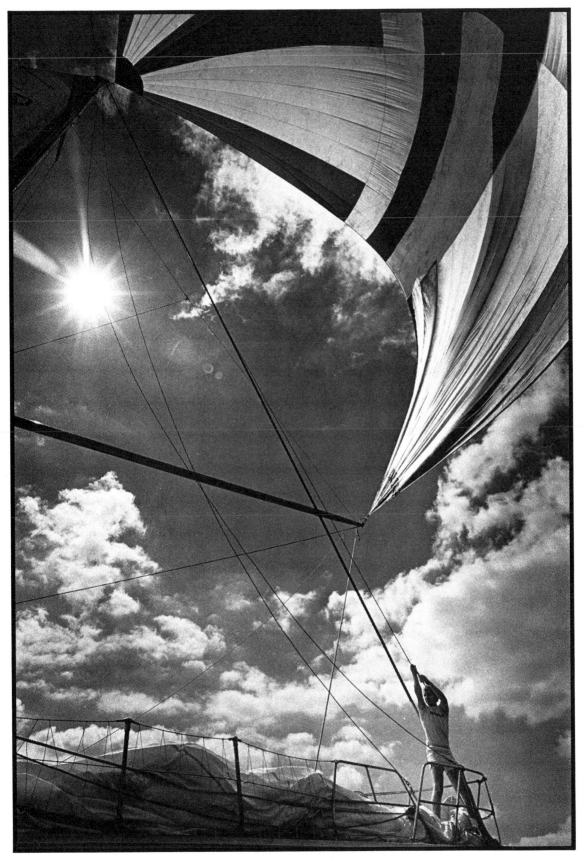

29. *Selective use of lenses produces a better average of more dramatic work. 35 mm SLR, 24 mm lens.*

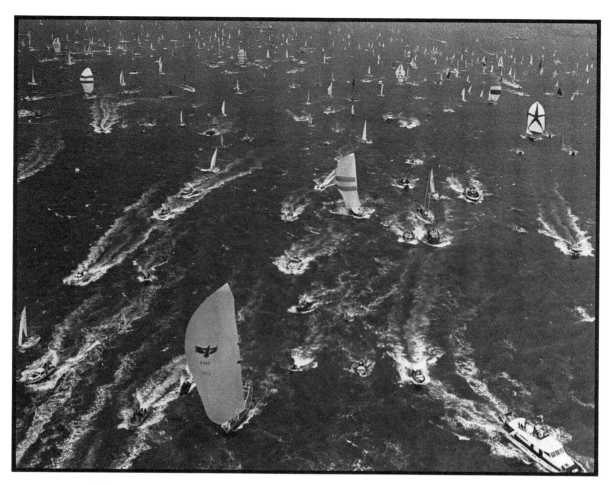

30. *Poor light is the photographer's worst enemy, but from the air even mist-shrouded events can be transformed. Start of a round-the-world race, captured by 35 mm SLR, 35 mm lens.*

28. (PREVIOUS PAGE LEFT) *The America's Cup is about a duel between two yachts. Telephoto lenses are essential because of the distance-off restrictions placed on photographers at this and other world class events. Novoflex 600 mm, from a colour print.*

6

COLOUR AND LIGHTING

BLACK AND WHITE OR COLOUR?

With a subject matter as varied, wide-ranging and colourful as the sea, it might be supposed that the automatic choice for film must come to rest in the colour department. There are many reasons for this, not least of which is that the traditional use of colour photography has been based on the assumption that the grand and colourful dimension of what we see 'live' is equally impressive when transferred onto a flat and relatively small piece of paper. However, few of the images we see are retained in the memory for very long and this is perhaps even more so with colour. A simple test of this is to recall to mind all the pictures that you can remember. The chances are that most photographers, apart from selecting their own work, will recall mainly images that were published in black and white. In the past few years, most of my output has been in colour. However, quite recently, when a portfolio of my pictures originally shot in colour was published in black and white I was surprised at how much more dramatic the overall effect appeared to be when set against the originals. Whatever the advantages and disadvantages of working with black-and-white or colour prints, the average colour print appears as a drab collection of shapes and colours compared with a colour transparency of the same subject. The thin paper base of the print cannot reflect more colour than is actually present and if those colours have a slight cast or there has been some contamination in processing which stained the paper, the effect is to subdue and discolour the result. The transparency, which relies on light transmission through the film to project the content, always appears brighter.

From a professional point of view, it has always been argued that transparency emulsions give far better reproduction quality than the colour print and anyone who has seen high-quality Kodachromes expertly projected will agree that even the best quality Cibachrome prints cannot compare. This has been due to the superior grain structuring of reversal (transparency) emulsions which enables them to resolve fine detail with clarity. High-quality scanning and printing techniques have enabled publishers to produce superb results.

However, since the introduction of 'T' grain structures in colour negative emulsions, quality has rapidly improved and the transparency no longer retains the dominant position it once did. Publishers the world over can now use the many extra advantages of colour negative materials to produce images that in many cases are indistinguishable from transparency reproductions.

Aesthetic appeal, as much as anything, determines the type of colour emulsion the photographer employs. The average colour print tends to be pale, less contrasty and less colour-rich than its transparency counterpart. It is my opinion that, good as colour prints can now be, the material lends itself to much further manipulation to produce a kind of print which could possibly have a higher luminance factor than printing papers currently give. The base colour of the paper, its thickness and a number of other factors would all seem to be ripe for further exploration by the major manufacturers. That said, however, existing materials used in the proper combinations and in the right hands can produce excellent effects, easily bettering the high-contrast and blocked-up shadow results obtained from transparencies printed directly without internegatives or contrast masks.

COLOUR NEGATIVES

Colour negative materials are generally more forgiving than reversal emulsions, particularly when it comes to exposure. The former have a great deal more latitude and some colour negative films can be pushed and pulled in processing to give similar advantages to reversal materials. The major advantage, however, is that it is much easier to produce black-and-white prints from colour negatives than from colour reversal film. All you need is a box of variable contrast printing paper, chemicals and an enlarger with a filtration facility. The same enlarger that you use for colour printing is ideal. Using Ilford Multigrade black-and-white paper, high-quality prints can be produced within minutes of making a colour print from the same negative.

Modern colour negative emulsions are now used by newspapers the world over in preference to reversal film, and their generous exposure latitude is much appreciated by photographers converting from black and white to colour. Newspapers can increase profits by the additional sales of colour prints to the public and, when colour is not required for publication, darkrooms can quickly adapt to black-and-white production. The printed picture can easily be converted to a transparency using low-contrast duplicating reversal emulsion or print film and the reproduced

result in each case always appears to me to be more aesthetically accept-able, whether on newsprint or glossy magazine coated art paper. The discerning photographer will notice the occasional reproduction of this type by the lightness of most colour print originated material.

POLAROID

One of the most pleasing colour print results can be obtained from Polar-oid print films used in a special camera back which takes the place of a conventional film magazine on cameras like the Hasselblad, Bronica and Rollei. (Polaroid backs are also available to fit some 35 mm SLR cameras including the Rollei 3003, Nikon and Canon F1N.)

Traditionally, professional photographers have used instant film technology as a means of checking exposure, composition and lighting before shooting the picture on conventional stock. Few photographers (except Marie Cosindas) have ever used the materials to produce the final result, which seems a shame when it is so widely available and easy to use.

Polaroid colour prints from the 669 series film have an amazing subtlety quite unlike any other medium. To expose the film properly, some care is required and the user should pay particular attention to the filtration, reciprocity and temperature processing details contained in the com-prehensive instruction sheet. With a medium- or small-format camera the print is a contact of the whole negative area, but this could be effectively enlarged after exposure and processing, as we shall see.

I prefer to use the 669 film with larger formats such as 5 × 4in. This gives a larger print with ample detail from which I can make any number of copies using sheet or roll transparency film and filters to correct any casts. Some of the colours obtainable are very close to the colours of old motion picture film used in the late 1930s. This was an additive-based colour film produced by Louis Dufay and known widely as Dufaycolor. Reds, blues and yellows are particularly noticeable, being unlike rendi-tions available from today's film stock. The supplementary colours of Polaroid 669 are layered onto a negative which is sandwiched to the print. Processing is effected by rollers in the film back squeezing caustic-based chemicals suspended in jelly from a pod. Colours not exposed are dis-solved away leaving a slightly discernible ridge outline around each layer of exposed and developed colour which is transferred to the print. The effect gives each Polaroid photograph depth which appears to become more pronounced the larger the format used.

In another experiment, I began using a cheap plastic Polaroid camera to see if it would be possible to use SX-70 type print film as a serious means of making portraits of yachtsmen and women. These experiments could be nothing other than elementary, since the camera had a fixed-focus plastic meniscus lens and a simple control to lighten and darken the final print. This film is very different from the 669 pack just described, although processing is achieved in the same way when the film is ejected from the camera.

SX–70 and type 600 Polaroid film have no negatives as such, the image being exposed onto a light-sensitive base through a very thin sheet of Mylar. Image development can take up to a minute and a half, depending on the ambient temperature. A mixture of titanium dioxide paste forms the brilliant white background for what is really a very overexposed colour transparency.

By establishing the exact hyperfocal distance of the lens and by applying certain coloured filters to correct the film for European daylight I saw that it would be possible, with a more sophisticated camera, to produce on-the-spot original prints of excellent colour quality. I moved up to a Polaroid 680 SLR which I knew had a very sharp lens. Its auto-focus mechanism, operated by means of an ultrasonic sound device, is also very accurate and rapid in operation. This gave me a print size exactly the same as the SX–70 but of superior quality, producing prints which could be enhanced further by copying onto reversal materials for reproduction. Using this technique also allowed other factors to be introduced during the shooting sessions. I could give a fully developed print to my subject within a few seconds of shooting to see if he or she approved my technique and, if they did, I would then ask for a signature on the print I intended to keep. To prevent scratches and dust from gathering on each print while jumping from one boat to another, I kept them in a small box used for computer diskettes. The Polaroid 680 camera, like sophisticated versions of the SX–70, folds flat to the size of a large cigar container and will easily fit in a jacket pocket when not in use. Film packs have their own integral flat battery and contain enough film for 8 shots. Careful copying of the originals with a 5×4 in camera using duplicating film produces very acceptable transparencies for reproduction, although I have had original prints used with equally good effect.

POLACHROME

Over the years, Polaroid have produced and marketed an amazing variety of film emulsions and at least one is available to most 35 mm camera owners today. Polachrome is a 35 mm colour reversal emulsion available in

standard cassette. Each film pack contains its own processing pod which is used in conjunction with the Polaroid 35 mm instant film processor. Polachrome has an ISO rating of 40. Its exposure characteristics are similar to those of Kodachrome 25 – critical, with probably even less margin for error. However, like Kodachrome, it has the ability to render reds, oranges, yellows, blues, browns, blacks and pinks in highly saturated vivid form. It does not like the presence of large quantities of ultra-violet light, nor whites or pale colours. It is best used when shooting contrasting colourful scenes.

Polachrome colours are achieved by the additive (as opposed to subtractive process of most conventional emulsions) process of combining very fine rulings of the three additive primary colours red, green and blue in a grid pattern which is layered over what is basically a black-and-white panchromatic emulsion. When viewed by very strong transmitted white light, the combining effect of minute specks of the colours on the eye and brain is such that we see the colours of the image in much the same way as we see the printed picture on a page. Colour television works on the same principle. When viewed against a point source of light with a lupe, Polachrome transparencies appear to defract the light into its spectral sources and this gives a very clear indication of how the additive screen process works.

The film's main appeal for me is its ability to add apparent richness to colours that sometimes appear muted. It goes without saying that colours often seen in brilliant and contrasty sunlight are all the more vivid. When viewed on a white beaded screen at full projector power, the overall effect is quite stunning. There is little evidence of the rulings on screen, or in prints which may be subsequently made on Polacolour print materials. Effective reproduction is difficult due to the higher density of Polachrome materials, but where allowances are made in the production of film separations, reproductions on the pages of a high-quality book can be very good.

Polachrome is a difficult film to use well, but results tend to improve with practice. It has a fragile nature too; even the hairs on a wool jumper will scratch and spoil the emulsion. Both contrast and colour can be further increased by processing the material using the chemical pod from Polagraph film stock, the results achieved depend a lot on how much money you are prepared to spend and ultimately waste.

COLOUR REVERSAL MATERIALS

Obtaining good results using colour emulsions is largely a matter of learning about the film materials you plan to use and the nature of the colours which surround us in everyday life.

I believe that understanding the limitations of particular types of emulsion and how they react to different lighting situations can go a long way toward helping the photographer decide the purpose and function of each photograph before it is made.

It used to be said that the ideal colour transparency for reproduction purposes should be at least half a stop underexposed, and some printers preferred a whole stop, to enable process film technicians to retain a high degree of colour saturation in the reproduction. However, reversal film stock, like colour negative materials, has benefitted enormously from the new film technology of recent years and continues to improve. Films in general use can accommodate a far higher contrast range than before and are thus able to retain full colour saturation even in areas of the subject close to the top end (highlight) while simultaneously recording all of the subtle detail at the bottom end (shadow). Except where underexposure or overexposure is necessary for a specific effect, transparencies should therefore be exposed as accurately as possible to obtain an image which is 'light and bright'.

Reproductions of quite ordinary subjects that have been deliberately underexposed in the belief that more colour will come through in the printed page look awful by comparison to a reproduction from an average-quality colour print. The overall image quality appears as a dark, muddy reproduction from which the average viewer can extract little useful information. It has to be said that despite all the technical teachings over the years, it was not until Olympus produced the OM4 with its sophisticated 'spot' with highlight and shadow meter that attitudes began to change. For years, photographers had been trying to expose correctly for the whole of a subject brightness range, no matter how high- or low-key the main subject. The result was invariably a compromise, manifesting some detail in, say, the lit side of a face and the net curtains, but losing virtually all detail in the shadow areas. This seemed to be perfectly acceptable for most people, but it just goes to show how easily and quickly we forget what the subject actually looked like in our mind at the time the exposure was made. Since the net curtain is only acting as a diffuser of light, it seems pointless to try and retain any detail in it. What the viewer needs to see is a clear picture of the subject's visage. To do this effectively, quite a lot of details must be retained in the parts which are held in shadow. The highlighted areas are less important, but certainly more important than the net curtain.

Instead of the usual centre-weighted average metering system used in most small-format cameras, Olympus gave the user the opportunity to make selective meter readings of very small parts of the frame using an

extremely accurate built-in spot meter which could be adjusted instantly for extremes of light and dark. Evidence of how far this improved work could first be seen in the expensively produced Olympus OM4, OM3 and OM2SP camera brochures!

Many other modern cameras now have similar metering facilities, so there should really be no excuse for poorly exposed colour transparencies. The key, once again, is to establish the function and purpose of the final photograph before the exposure is made. If we are communicating information, the transparency image should be accurately exposed for its correct ISO speed wherever possible, producing a crystal clear and evenly colour-saturated picture which can be viewed easily in ordinary room or daylight conditions. If we are out to please, that intention should be clearly stated in the photograph, using whatever manipulative exposure skills are necessary to achieve the end result.

LIGHTING

Lighting conditions near the water vary so widely that it is difficult to recommend specific exposure techniques. As a general rule, light intensity is far brighter at sea than it is on land. The sea acts as a huge light reflector, which has a tendency to increase exposure factors. On land, the same exposure as used at sea would almost certainly overexpose the subject by at least a full stop and possibly by more. Exposing for white sails against a deep blue sky will generally cause underexposure of the overall image. Since it is in any case difficult for the eye to see great detail in a white sail, except at very close quarters, better results will be had by exposing for the middle tones of the blue sky.

Wind-ruffled seas are better reflectors than calm seas, which often appear very dark or even black when there is blue sky overhead. The degree of darkness is also indicative of how deep the water in any given area may be. Bright, turquoise-coloured seas are usually the result of light refracting through very clear water and reflecting off shallow, sandy bottoms. Different kinds of algae and plankton suspended in the water also affect its surface colour. A polarising filter can reduce many of the spectral reflections and actually diminish the effect of colour as we see it without the camera. Around the coasts of Europe and North America, these exotic sea colours hardly exist. In Europe especially, coastal waters are constantly churned by Atlantic gales, so minute particles of sand and mud, as well as many chemical pollutants, perpetuate a colour that is mostly drab, and uninteresting but is nevertheless useful because of that. As a neutral

grey sea-green, can be used effectively to enhance other colours which float on it.

COLOUR PROCESSING

The basic colours of most reversal materials vary widely. No two films of the same ISO speed manufactured by different firms give the same or even similar renditions. The experienced photographer will have preferences and will know that some film from the same manufacturer with the same ISO rating can produce a different result when used in varying formats but shot under identical lighting conditions. Furthermore, another variable is introduced when the film is sent for processing. Two batches of the same film exposed at the same time of the same subject sent to two different laboratories will invariably return with a different set of colours in each batch. It is important to find a processor who meets your requirements and stick to them.

In Europe, Kodak's Kodachrome has to be returned to the manufacturer for processing, but even using products from a company with an established reputation for high-quality control is no guarantee of consistency. Kodachrome Professional film is generally more reliable in adhering to colour characteristics than the non-professional versions. The rendition of colours in the large-format versions of this film is different to those in the 35 mm format and the characteristics of each should be clearly understood by the photographer before undertaking any special assignments. The hues rendered by the larger-format Kodachrome 64 are quite different to those from E–6 based materials in the same or larger formats, but for some subjects, Kodachrome may render a more faithful image.

Push-processing is common with reversal materials, but since there is now such a wide variety of high-quality material available with an extensive range of ISO ratings, it hardly seems necessary to uprate a slow film when the faster rated version of the emulsion will probably produce a better result. At sea, in normal light conditions, exposures tend to be at the fast end of the scale rather than the slow. Even Kodachrome 25 can be exposed at 1/500 second at f/5.6.

BLACK AND WHITE

The commercial need for black-and-white photography would appear to be as strong as ever, although, increasingly, newspapers are converting

entirely to full-colour printing capability, with their whole production geared to that end. Photographic departments use only one type of film – colour negative – from which editors and production staff may make a choice for publication.

Some book publishers are tending to follow the same route, commissioning the original work in colour and running it black where necessary. Colour development and printing processes are now much simplified from what they were and, as time passes, likely to become more so. The effect will be to make black-and-white stock redundant except for high-quality, specially commissioned works.

The enthusiast, exhibitor and dedicated black-and-white worker will remain, however, as reinstatement of certain old-time favourite products by major manufacturers continues. At the time of writing, there is a very wide range of black-and-white film and paper products available to the enthusiast. These include standard panchromatic films in a variety of formats which use fairly old technology in their granular construction. There are also newer films which use the same kind of grain technology as high-quality colour negative materials. These are said to give sharper images but often do so to the detriment of negative contrast. Finally, there are films which produce black-and-white negatives using the C–41 processing chemicals of colour negative materials. The advantage of this is that if you do not have any processing facilities, your films can be developed by any high-street processor.

Paper materials vary from a wide range of resin-coated, polythene, contrast-graded materials to more conventional fibre-based papers, as well as lightweight stabilisation papers suitable for lick-and-dip rapid processing in special machines. All of these products and combinations of them can be used to produce results ranging from exhibition to snapshot standard. Producing excellent high-quality black-and-white prints in a consistent manner requires skill, patience and a sound knowledge of exposure techniques. With lighting conditions on the water continually changing and usually a lot brighter than those found ashore, exposure values are correspondingly higher. If you are accustomed to using film with high ISO ratings, you may find that your development techniques will need major adjustment in order to produce high-quality negatives which retain all the detail and contrast which you have grown used to ashore. The use of filters to darken skies, lighten seas, darken or lighten woodwork; and the use of compensated exposure and development techniques are recommended. Ordinary metering techniques and those used when exposing colour reversal materials should be changed. The manufacturer's recommended ISO setting for some films may not produce the best negatives and in many

cases only trial and error initially can establish the best ratings for a given method of development.

Some years ago, I carried out a number of experiments to establish a suitable exposure/development compensation table (the full explanation and details of which are published in *Essential Darkroom Techniques* (Blandford Press, 1987)). It works on the simple premise that if exposure is increased, development must be decreased and vice versa. The best results are obtained by conducting experiments with one type of film using 5 or 10 per cent increments in each direction to establish a new effective EI (Exposure Index) for the material with one type of developer. The type of paper used can be chosen at random for its tonal and contrast qualities. Provided the photographer continues to use similar paper and similar film processing and exposure techniques, work produced should be of a consistently high quality.

As the use of colour increases, so black-and-white photography appears to gather a hitherto unknown mystique. There is absolutely nothing mysterious about the medium or the production of high-class work. Anyone who can read the instruction leaflets packed with film, printing paper and processing chemicals should be able to produce an acceptable negative or print within a very short space of time. The key to success, as always, is a thorough understanding of exposure techniques and what happens to different types of film when they are exposed to light.

For those who have no patience for the delicate skills of darkroom work but who want to work in black and white, the answer could be a black-and-white reversal film made by Polaroid called Polapan. It has a thinner base than most conventional films and is processed in the same way as Polachrome and other 35 mm Polaroid products. A mechanical and electrically driven version of their film-processing unit is available which allows the production of fully developed film in a matter of minutes in daylight. The processing unit is no larger than a standard-sized shoe box and can therefore easily be transported to the field for an instant analysis of the work being shot.

For the professional, Polapan provides a quick method of checking lighting, composition and exposure as well as the production of high-quality originals in transparency form which can, if necessary, be made ready for reproduction soon after exposure. The only flaw with this material is that, like its colour counterpart, the emulsion side of the material is susceptible to scratching. Great care must be taken in handling the material and informing publishers of the risks involved.

106

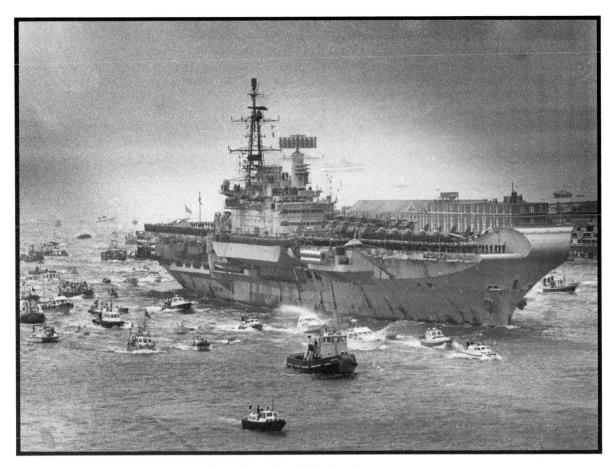

31. *A warrior returns:* HMS Hermes *home from the Falklands, taken from the Semaphore Tower in Portsmouth Dockyard.*

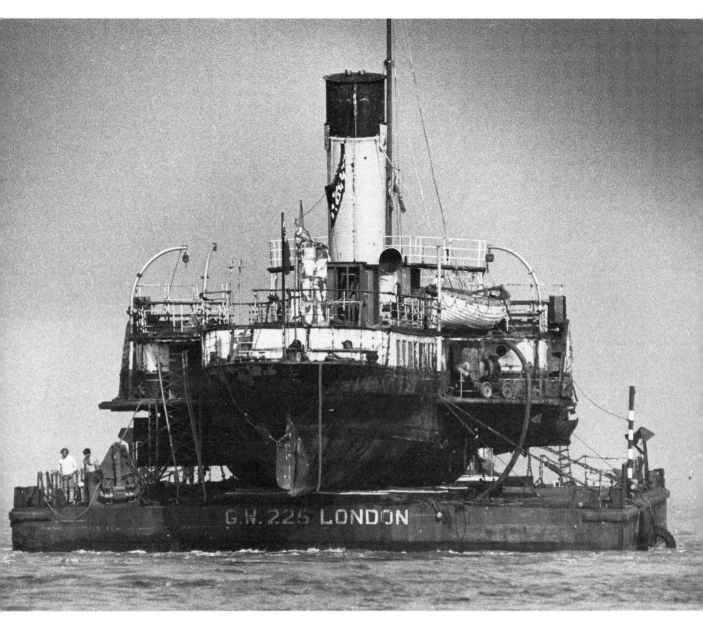

32. *The* Medway Queen *goes home – one for the record. Novoflex
400 mm.*

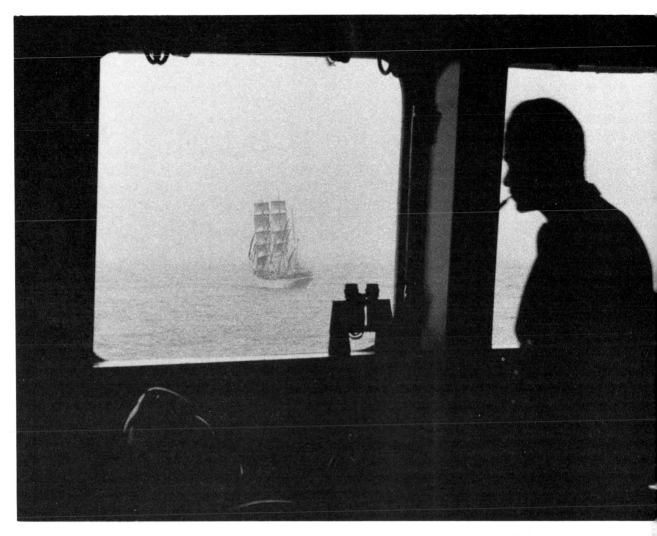

*33. Keeping an eye on her course: the Norwegian sail-powered training
ship* Statsraad Lemkhul *on passage down the Channel.*

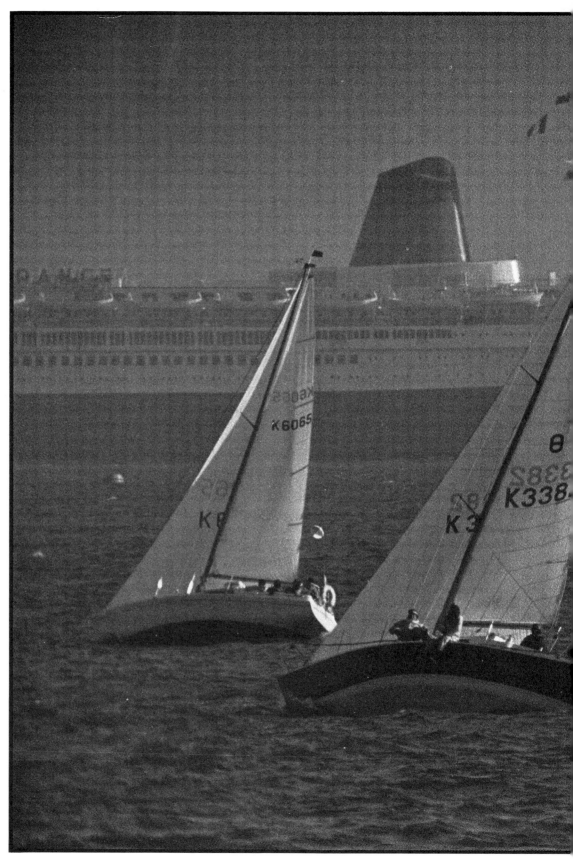

34. *At least two miles separated the liner SS* France *and the yachts.
Advance planning helped to make the picture.*

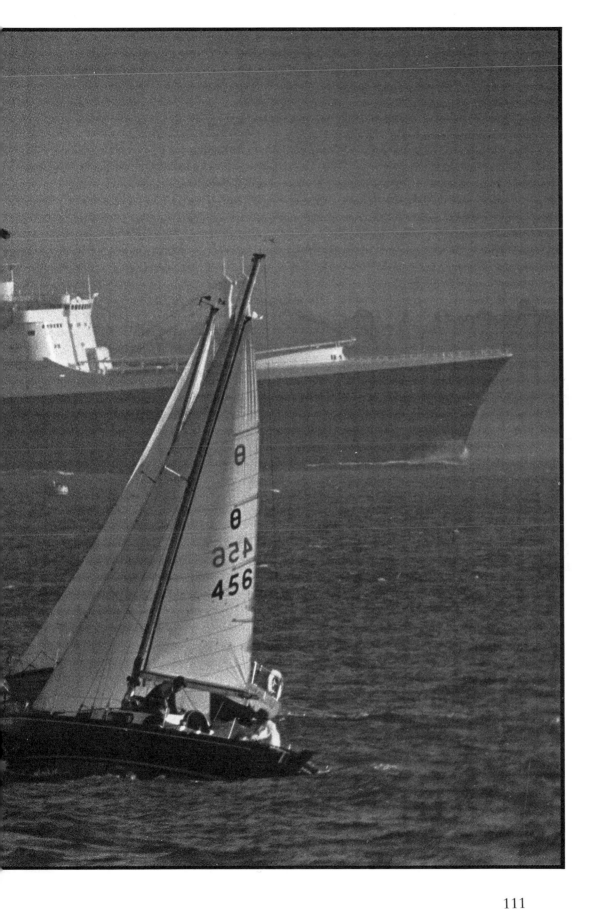

35. *Oops! The Egyptian pilgrim ship* Mecca (left) *on her way to Jedda, hit the* Auckland Star (centre), *which was at the time towing the* Indian Merchant (right). *Taken from a segment of a 6 × 6 cm negative. It became my first published picture.*

7

WORKING AFLOAT

To many, yacht and powerboat racing may seem to be confined to a relatively minor section of the small-boat fraternity. Nothing could be further from the truth. It is an international sport which is conducted worldwide at all times of the year. One look at the events calendar will show that there is barely a break between events; many, in fact, overlap each other. Dedicated marine photographers will therefore have no trouble in finding enough work to keep them occupied and in addition are provided with an opportunity to travel far and wide in the search of pictures.

METHODS OF WORKING

Aside from the international scene, there are more than enough important events staged in home waters to keep the industrious busy. With the British Coast at most a couple of hours away, I know of a number of 'landbound' photographers who happily travel the country with a small outboard-powered launch towed behind their vehicles. This gives them the freedom to go to any location around the coast and get afloat, to carry out the work being asked of them without the extra hassle of having to find a suitable working platform and a driver. The financial view is that while the initial investment in hardware may be high, it will more than pay for itself over a fairly short period of time, provided it is being worked on a regular basis. The enthusiast is much better placed, having only to consider whether the return on investment is going to be enjoyable.

The photographer specialising in editorial work, rather than commissioned boat portraiture, may find that the investment and maintenance costs for a small boat are not economic and he or she would therefore do better to charter a boat as and when required. I rarely go to the trouble of trailering my own boat around the coast having found, over the years, that when the occasion arises, it is actually easier and more economic to charter a boat on the spot. Valuable time is often saved in not having to worry about where to park, where to launch and in seeing that the boat is carefully secured after use.

113

If my deadlines were not quite so immediate, I might well consider trailering worthwhile. There is also the other argument that if you own the boat and can take it wherever you please, the scope of subject material – fodder for the camera – is bound to increase. Readers who have a boat of their own will doubtless know the pleasure that can be had from exploring unknown creeks and estuaries on a flooding tide in the calm of a summer evening. Many will also know the excitement of being able to join the spectator fleets attending a parade of tall ships, a naval review, yacht regatta or powerboat race. In chartering, time is of the essence because of the cost factor. (Mile for nautical mile, it is much cheaper in your own boat than in one being hired by the hour, especially if part of the cost is for the skipper and any crew.) I am therefore less inclined to wander off and investigate potential pictures.

In short, it is important to establish methods of working which suit your pocket, your character and the needs of the type of work you hope to do.

In the earliest days of marine photography, practitioners used small, open boats which were either rowed by themselves or handled by local longshoremen. Looking at the legacy of work by photographers like Frank Beken, one can only marvel at what dedicated photographers were able to produce, and how simply they were able to do this. By stationing his platform at a position likely to bring the big yachts of the day within acceptable distance, Frank Beken made some of the most memorable boat portraits ever taken. The Beken family is still working out of Cowes and, in many respects, use the same methods perfected by the founder of the firm. Son Keith and grandson Kenneth now use high-speed launches to enable them to reach their locations easily, but they still photograph their subjects at a respectable distance. They are helped because everyone who goes yachting knows of the family, and their work boats are easily recognised, having the name of the firm painted down each side in large letters. Yachtsmen seeing these craft in their path are rarely anxious about the possibility of an impending collision because they know only too well that a Beken photographer is in full control of the situation. Their track record has been impeccable.

But there are few photographers in the world with such an established reputation for a particular style. Many photographers, myself included, are after another kind of image: one which demands a different, more aggressive approach to the subject. To obtain these images sometimes involves an intimate connection with the subject. The best way of achieving this is by means of a small, high-speed, rigid, inflatable craft. These are highly manoeuvrable and, if in collision with yachts, can do very little, if any, damage because of their soft neoprene buoyancy tubes. They are not

usually as comfortable to ride in as conventional craft, and should never be used in close-quarter situations unless skippered by people who really know what they are doing. It is all too easy to misjudge a wave or the suction factor of a large-subject boat travelling at speed.

As discussed in Chapter 5, great teamwork between the photographer and skipper makes many things possible. If you are in a hired craft and unsure of how much the helmsman knows, it is always far better to take the stand-off position and do as well as you can with the optical equipment available. Looking back over my career, there have been surprisingly few occasions when I have had to adopt the distant viewpoint because I was apprehensive, or the boat pilot set my nerves tingling. Boat owners/helmsmen, though not always familiar with the requests of slightly eccentric devil-may-care marine photographers, are mostly more than competent and confident when it comes to close-quarter manoeuvring.

One valuable advantage of the larger photo-boat is its extra height above sea level. In boat-to-boat photography, these extra few feet could be essential if the shot is to give a clear view along the deck of the subject boat. Several examples are shown here and the reader will see that some have been taken from the stern-quarter position. This is a useful position to try and set up especially when the subject is sailing close to the wind or on a reach. The photographer is comparatively safe from being run down by the subject boat, the skipper of which may be frequently glancing over his shoulder to see where his nearest competitor is. Once he is aware of your presence, he or the crew will be able to warn you of any impending alteration in course.

Working off the bow is more difficult, especially if the photographer is trying to obtain close-ups of the fore-deck crew at work with short-focal-length lenses. Photo-boats which are underpowered or which cannot travel significantly faster than the subject boat should not attempt to get into the sort of position that is likely to lead to trouble. An extra puff of breeze can easily give a yacht under full sail an extra, unexpected surge in speed. Neither photographer nor photo-boat helmsman may be aware of what is happening until too late.

Where possible, warn your subject in advance of what you plan to do. Some boat owners are very co-operative; others may be of a more nervous disposition and when they actually see what is happening can do all sorts of peculiar things. If you are waved off, take the advice and stay away. It is not worth risking damage to boats or people for a picture which may not have worked anyway.

Many of today's sail boats, even the family cruising type, are capable of a fair turn of speed. Large and powerful ocean racers can easily outpace

the average fishing boat upwind, and downwind in a good breeze can reach 18 knots or more. These are speeds which even some twin diesel-engined power craft will be hard-put to maintain. On several occasions in recent years, my helmsman has had trouble mounting the quarter wave of a big racing yacht under full sail, even when in a normally fast, rigid-hulled inflatable with a 60hp outboard.

Photographing motor cruisers and powered craft is not necessarily easier than coping with the vagaries of a yacht under sail, but the nature of powered craft usually makes it easier to set things up so that the photographer has a chance of producing acceptable work. While it is perfectly possible to shoot powerboats from fixed, land-based positions, it is more desirable for the photographer to be afloat. Both boat pilots should be expert and a serious briefing by the photographer before the shoot starts is essential. Details can be changed at sea by stopping and holding conferences alongside or by using a VHF radio.

PLANNING THE SHOT

Running shots can be set up in a number of ways. The easiest and usually the most successful, is for the photo-boat to proceed ahead of the subject on a straight course at a reasonable but not excessive speed. The subject boat is required to approach from some way astern, aiming at the transom of the photo-boat and peeling off to left or right when the moment seems appropriate. This technique gives the photographer ample opportunity to produce reasonable running shots and to snap the occasional picture as the subject bounces across the trailing wake of the photo-boat.

Illusions of power and sleekness can often be created by chopping the subject in half – photographically speaking. But remember that if you are working to a customer's brief to provide general pictures of the whole boat, you should leave the creative stuff until you are sure that you have captured what the client wants.

Once you have gauged the degree of competence with which the boat skippers handle their craft, you may then be able to take things further, but briefing the helmsmen of your intention is the most important factor, because whether your picture is successful or not will depend largely on their ability and nerve. An example of how some pictures come about is clearly illustrated in the picture of the motor cruiser *Fairey Fantome* which, if it had come any closer, would have been in the cockpit of the photo-boat for lunch!

Having spent most of a fairly dull morning stooging around the ocean under a grey sky and making various exposures with a medium telephoto lens, I felt the session was in danger of producing nothing much other than a fairly ordinary selection of prints. As I knew both pilots to be experienced and the sea state was reasonable, I switched to a wide-angle lens and called up the subject boat to come aboard, peeling off only when I gave the signal. I had to hope that I would be able to see instantly the moment that both boats would be at risk of collision and warn the subject boat helmsman soon enough, as well as hoping that he was expert enough to put his boat where I wanted it the first time round, because I somehow doubted that anyone would want to repeat what I had in mind.

It all appeared relatively straightforward. Engines roared and we tore off down the Solent to assume the course. The subject boat took up position astern and gradually, inch by inch, climbed our wash and sat poised for a second or two with its pulpit rail overhanging my head. We hit a slight swell, the direction of our wash changed, caught the subject's forefoot and spun it outboard and away from the camera. I was shooting fast as the boat vanished from the frame, but only one shot produced the picture I had hoped for. The conditions were right for a second or even a third attempt, but the risk of the two boats colliding was too great as we could see from the way the subject boat suddenly tripped off forwards. The boat could just as easily have slid the other way, the consequences of which I do not like to dwell on. It is certainly something none of us would have ever tried if there had been any sort of running sea.

A running sea produces conditions in which many of the better pictures are bound to be shot, simply because of the drama and animation which the sea condition brings to the subject. A motor cruiser powering up the side of a wave and surfing off the top presents spectacular opportunities for the photographer afloat. Yet the very state of the sea can present problems, too, not so much for the subject craft, as for the photographer. The larger the platform, the greater the chance of success because of the stability factor, but there is no guarantee of this. The sea has an uncanny way of throwing even the biggest boats around as if they were corks in a bath tub. The photographer needs excellent sea legs and a safe position from which to work. This may mean being wedged in a doorway, using a suitable stanchion or ladder as a grip; it may even mean, in really severe conditions, being strapped to a convenient support, though I would never recommend this on a powered craft because of the unpredictable way certain boats react in a seaway and of the very real risk of injury. To counteract the way of a violent sea and the performance of any craft in it, the body needs a degree of freedom. It is a little like being on a perpetual

motion trampoline. The take-off and landing are always the most dangerous aspects of heavy weather and a body which is strapped in place has little or no chance of survival when it comes to bracing onself for the inevitable crash landing. I have seen inexperienced photographers being thrown about like rag dolls and equipment lost or irreparably damaged in quite moderate conditions in small boats. Unless you know what you are doing, what to expect and can be fairly sure of a worthwhile result, such conditions should be avoided.

Assuming the bow position where all ahead is clearly visible is extremely unwise, also. Except on a few well-designed craft, this is usually the worst possible place to be as, in a seaway, the average motor cruiser tends to ship large quantities of water over the forward areas, drenching photographers and their equipment before the day's work has started. Few pictures are ever worth ruining equipment for. Much better to stay dry, miss a few interesting snaps and wait until the boat is on station where the real action takes place.

CREW OR PASSENGER?

The chance to go afloat on a thoroughbred racing yacht provides a unique opportunity for the photographer, not only to see life from the other side of a guardrail, but to be involved in the on-board life, its tensions and emotions, to make the kind of pictures of a close-knit community and its immediate environment which are less frequently displayed in books and magazines.

The reasons why comparatively little on-board material is available are because on a big racing yacht the crew have little time or inclination to take their own pictures and photographers are not very often invited. To the skipper, the photographer is an extra and unnecessary weight; a hindrance and another mouth to feed. Photographers cannot take pictures every minute or hour of a race, so what are they to do while sat fumbling with an aperture ring? On a long-distance race, photographers can get involved, do the washing up, even cook if they are of a mind. Others with sailing experience might be useful on deck or even take a turn behind the wheel. Since yacht races, even relatively short ones, can last a long time – days rather than hours – there are times when the man with the camera is apparently at a loose end. Depending on the nature of the photographer this could spark unwanted emotions among a crew who are hard-working and out to win.

In the past, whenever I have been invited to sail on a racing yacht, I have accepted on condition that the skipper tells the crew that I am the resident

photographer – there primarily to make pictures, not to act as cook, dish washer or spare hand. If I am at a loose end (rare), I will be only too willing to pitch in with whatever help is required, but if, while I am pitching in, the opportunity for a picture arises, I am going to drop the rope and pick up my camera. On that understanding, I have had some excellent assignments on many different types of craft and I think that, on the whole, if crews see that you are nearly always busy, but not afraid to pitch in when required, mix easily and go about your job in a manner which indicates a professional knowledge of crew work and general seamanship, acceptance comes easily. The photographer resident on a long race or voyage will probably be most appreciated at night when, at best, the number of pictures available are going to be few and far between. Making snacks and hot drinks for those going on and coming off watch is always appreciated.

The most useful lenses on board a yacht are the wider ones, 18, 20, 24 or 28 mm plus a standard lens of around 40–65 mm and a portrait lens of between 85 and 105 mm. Longer lenses will get less frequent use, but they are handy to have none the less. You will need a small flashgun, a pocketable torch, and, if you are using a second gun, connecting leads or slave units, electrical insulation tape, small screwdrivers, pliers and cramps for installing cameras in awkward places – the top of the mast, for example, if it is impossible to get right to the top yourself. Always take plenty of alkaline batteries for power packs, motor drives and flash units. On a small yacht there will be little opportunity to recharge ni-cad batteries, but you may be able to use a 12V supply if there is one. Check that your equipment can handle the voltage before connecting.

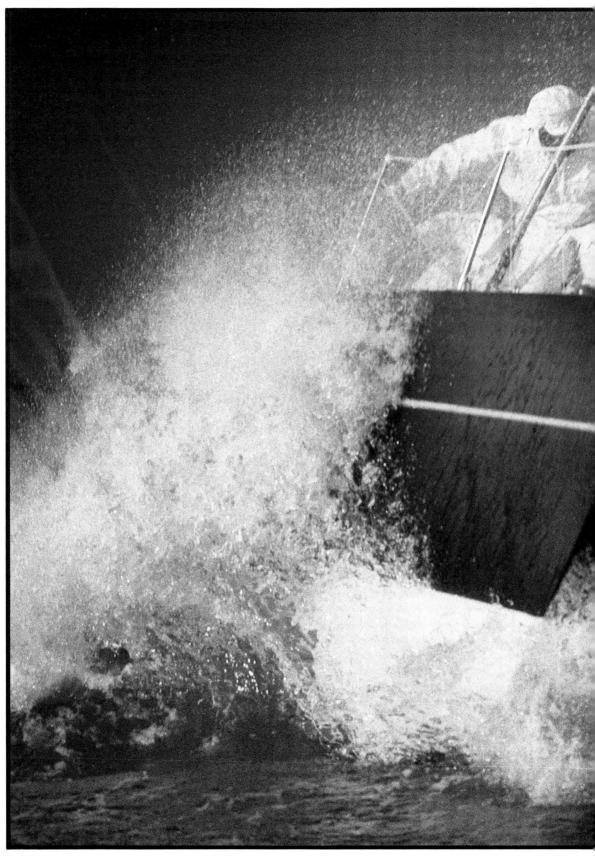

36. *Start of a Fastnet race in 35 knots of wind from a 20 ft launch. Under these circumstances you just keep shooting for as long as the equipment stands up. Olympus OM1n, 300 mm lens. See also plates 38 and 39.*

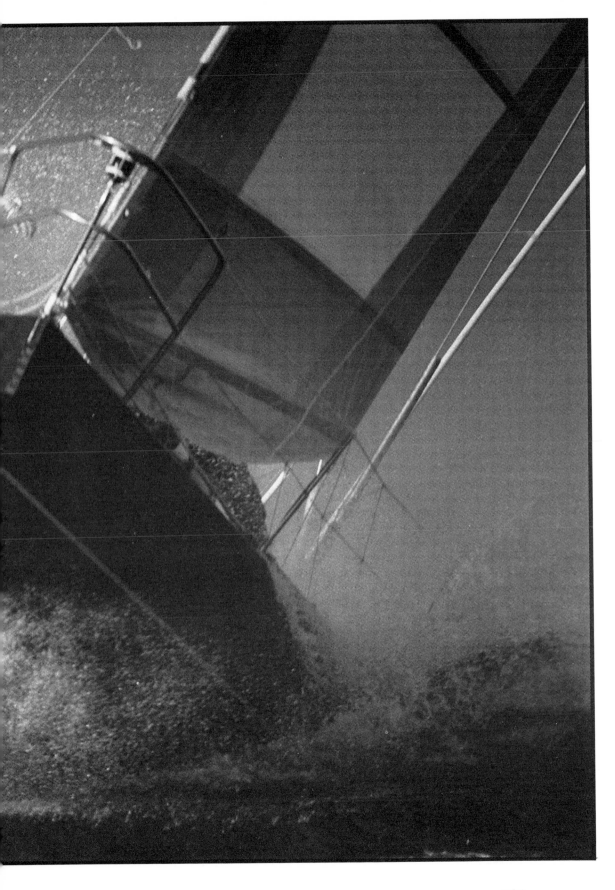

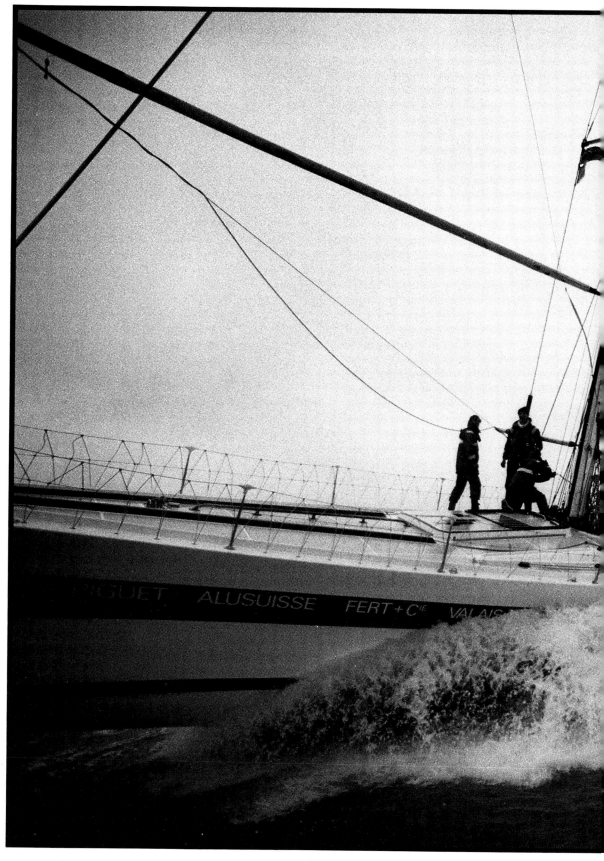

37. Round-the-world race-winner UBS-Switzerland *surfs to the finish.
OM1n, 17 mm lens.*

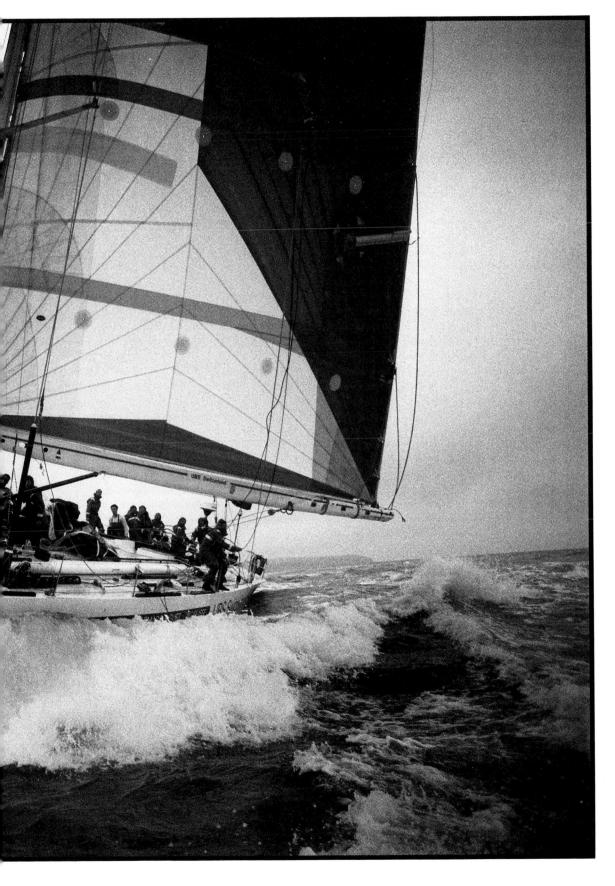

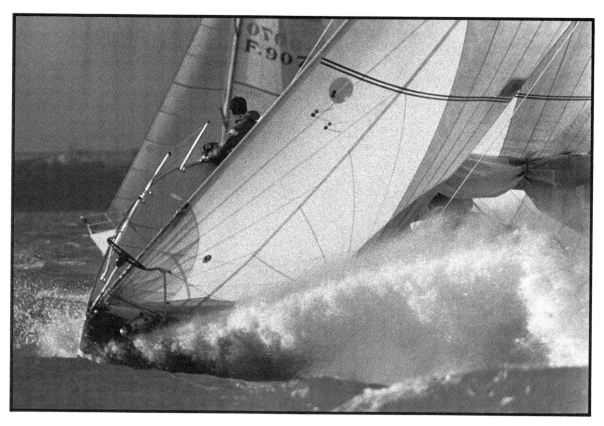

38 & 39. Rough conditions at the start of a Fastnet race. See also plate 36.

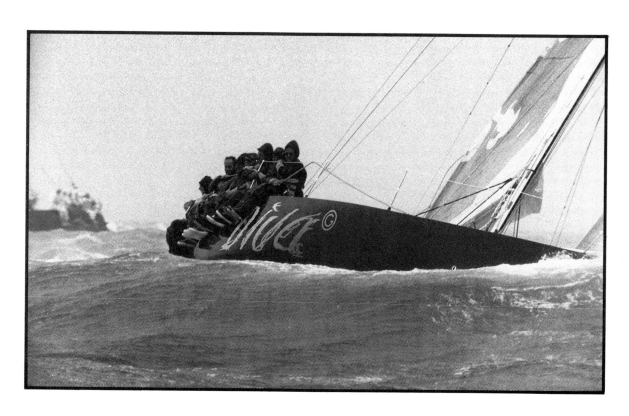

40. *Heavy weather in the Bay of Biscay. The platform was a fully loaded oil tanker with decks frequently awash. 35 mm SLR, 100 mm lens.*

125

41. *Plunging freighter in a stormy South Atlantic, en route to Liverpool.*
35 mm SLR, 40 mm lens.

8

IMAGE STORAGE AND CONSERVATION

A consideration for all photographers who aim to keep some of their work for any length of time, is the permanence quality of some emulsions; what museum curators call the 'archive factor'.

From the experience of picture libraries, and experiments carried out by film manufacturers and independent groups, Kodachrome appears to have a substantial edge over most other emulsion types. E–6 reversal films, when properly processed, dried, sleeved in the right materials and stored in a dark, cool place with controlled temperature and humidity, will last without fading for up to, and sometimes exceeding, a 20-year period. Frequent use of a transparency in the professional world can cut that time by two-thirds or more which is why it often pays for the photographer to spend money on high-quality duplicates; their cost might be insignificant compared to the loss of a picture that is historically important, or simply one which is a good money spinner.

If archive permanence is an important factor, then only top-quality emulsions, processing and storage facilities should be considered. Cheaper films, often advertised in the trade press, are frequently produced using redundant, out-of-patent formulae and processing quality is difficult to control when a film can only be developed in a lab thousands of miles away.

Film of all types generally has a longer life than the paper-based photograph and, of these, reversal emulsions tend to outlast most negative-based materials. Exhibition photographers would be wise to shoot original images on Kodachrome and use Cibachrome materials for second-generation prints. Kodachromes stored in temperatures averaging 20° C (68° F) with a relative humidity of 30–40 per cent could last 50 years before there is any sign of colour fading or breakdown of the emulsion support. Originals stored at −15 to −18° C (0° F) will last indefinitely.

Apart from manhandling by art editors and printing technicians, most damage to original colour transparencies is done by photographers. Storage is the biggest problem as well as the relatively high expense of good-quality PVC- or plasticiser-free storage materials such as transparent

sleeves and envelopes. Sheets of mounted transparencies should be hung in steel filing cabinets and not stored flat where pressure is exerted by upper layers onto lower layers, causing emulsion surfaces to stick to the covering sheet. Condensation in poorly ventilated areas can also do immense and rapid damage to materials. Individual transparencies can be stored in smaller filing cabinets of the card index size, but each image should have its own viewing envelope. In an ideal world, each envelope should be inserted in another outer cover with a low pH factor. This is used to identify each picture within.

Several other storage methods exist for collections of pictures that need to be well protected and filed in some sort of sensible order. The Journal system marketed by Kenro in Britain provides mass storage for individual transparencies in solid plastic cassettes which can be extracted from the file for viewing without the need to remove the contents. This system takes up more space than flexible viewing sheets, but the cassettes are rugged and provide a great deal more protection for valued materials.

Important collections of photographs, whether old or new, need to be carefully conserved if they are to last. As I have already mentioned, the cost of lignum, sulphur-free, unbuffered materials with low pH factors tends to be high and this alone is often an unwanted additional burden to individual photographers who are under-capitalised. Unfortunately, there is no real alternative if long-term conservation is required.

When I began to get concerned some years ago that a fairly large percentage of the picture library appeared to be rapidly deteriorating, decisions about the future had to be made quickly. At that time, the picture library contained some 150,000 images mostly held on black-and-white negatives, prints and colour transparencies. I took the drastic step of pruning the collection by dumping more than half the material I felt had little chance of achieving a reasonable commercial return. Surprisingly large quantities of black-and-white prints on early resin-coated papers had to be discarded also. These were only a few years old; but older prints on fibre-based papers had lasted well. The remainder was then scrutinised closely to weed out any further material which was either not up to the normal standards of sharpness, or was badly exposed. That left me with about 35,000 useful images which are now being carefully refiled and protected with long-term storage materials obtained from Conservation Resources International (USA and UK; see page 132). Several years ago, their UK Managing Director Mark Vine produced a small leaflet which will read like a mini-horror series to any concerned photographer. I am grateful to the company for allowing me to reproduce their guide here.

PHOTOGRAPHIC PORTFOLIO CHECKLIST (the DO's and DONT's)

(© Conservation Resources (UK) Ltd 1986)

Don't directly handle original transparencies, negatives or glass plates.
Do pick up this material at the edges only, *never* touching the inner areas of the item. Try and avoid using even archival-quality negative envelopes if they possess a thumb cut at the open edge since this will encourage user mis-use. Wherever possible, handle material using suitably fitting researcher gloves.

Don't try to polish or clean smears from transparencies, negatives or glass plates and *never* use spray or liquid cleaning products since most contain harmful chemical abrasives that will at best scratch and at worst discolour your images.
Do, in cases of extreme image defraction, seek qualified photographic conservator advice on suitable treatment.

Don't re-use photographic paper print boxes to rehouse prints, transparencies, negatives or glass plates even if you have used archival-quality storage enclosures first. Practically *all* the paper-print boxes sold today (and certainly those from yesteryear) contain a very high acid, lignin and sulphur content that will, even after short-term contact, lead to image fading, tone loss, surface deterioration and discolouration.
Do look for archival-quality photographic storage boxes that are not only acid-free but also free of lignin and sulphur. For ultimate print, transparency, negative or glass-plate storage look for boxes that are chemically buffered externally but have a non-buffered interior and are separated from each other by an inert polyester lining (not polythene) to prevent contamination from either side. The chemical buffering used in boxboard products will often be calcium carbonate. Look for a level no higher than 2–3 per cent.

Don't store glass plates in wooden boxes or cabinets. Wood oils and adhesives use in construction will cause image loss and tarnishing.
Do use upright archival-quality photographic storage boxes, preferably with each plate individually housed in a suitable enclosure.

Don't use standard translucent, glassine or clear paper transparency, negative or print envelopes or wallets for original quality material. Practically *all* of these products are constructed from inferior quality materials most being high in sulphur, lignin and acid content with poor adhesives used.

These storage products will, even after short-term contamination, cause image tarnishing, tone loss and base deterioration, the breakdown of poor adhesives used creating severe long-term difficulties.

Do specify archival-quality photographic storage products. Use 100 percent rag or alpha cellulose pulp base paper negative envelopes for your original quality transparencies, negatives and glass plates. These envelopes are buffer-free, have a neutral range pH and are sulphur-, lignin- and acid-free. They are constructed with archival-quality adhesives, have no thumb cuts and only edge and bottom seams.

Four-flap enclosures may also be used. These have no adhesives and form a neat-fitting enclosure around the transparency, negative or plate.

Enclosures need to be rested on a flat surface for item removal. Each flap is then carefully opened back to reveal the whole transparency, negative or glass plate which may then be picked up easily by the edges. For paper prints, use inert archival-quality photographic polyester sleeves or wallets but avoid opaque-backed transparent-fronted products purporting to be of archival-quality, since practically *all* have an inorganic physical abrasive permanently embedded into the surface of the polyester that will scratch any image removed or inserted more than once.

Seek professional advice immediately if your collection includes nitrate material since these items require specialist handling and storage.

Don't store copy or quick-reference transparencies or negatives in transparent PVC, polythene or plastic page or wallet products. *Most* contain high proportions of acid and lethal (for your images) plasticisers that will, even after short-term contact, lead to image fading, tone loss and base deterioration. Embrittlement of the base material leading to yellowing will at best stain housed material and at worst create complications that may necessitate professional conservator assistance to enable safe removal.

Do look for archival photographic quality, PVC-free, plasticiser-free and acid-free polypropylene page products with top-loading construction to reduce damage through over-handling of material.

Don't use even archival-quality storage products, without first ensuring their composition and construction are suitable for photographic purposes.

Many archival-quality products are not necessarily suited to protection of photographic-based products since they may, despite being termed 'archival' and 'acid-free', still contain high enough levels of lignin and sulphur to cause image fading and deterioration.

Do check the construction of all products you plan to use. Transparencies, negatives and glass plates should *never* be stored flat since this will lead to base deterioration and, in the case of plate material, may cause fracturing.

Print material should, wherever possible, be stored flat in one- or two-piece storage boxes. Check the construction has enough body to protect the appropriate format and that no internal stitching, flaps or composition will cause future interference.

Use well-fitting storage products and matching protective boxes and *never* overcrowd or mix formats (different-sized items in the same box can lead to surface marks or creasing).

Look for specifications that include 'lignin-', 'acid-' and 'sulphur-free' and, for more superior material, products that may be buffer-free or contain a combination of buffered and un-buffered qualities.

Don't store, mount or try to protect paper prints with standard quality folders or mounting boards. *Most* contain very high percentages of lignin, acid and sulphur and will lead, even after short-term contact, to image fading, tone loss, discolouration and embrittlement. Some archival-quality mounting boards contain both lignin and sulphur although classified as being acid-free.

Do use archival-quality photographic folders and mounting boards that are specified as being acid-, lignin- and sulphur-free. The more superior archival photographic qualities will also be buffer-free and free from harmful dye additives. They will have a neutral pH range and 100 per cent rag or alpha cellulose content. When coloured mounts are required, use a suitable inner lining of two-ply or two-sheet archival photograhic mounting board to separate the photograph from the colour window mount/mat. Look for archival-quality water-moistenable hinging tapes or archival-quality see-through photographic mounting corners.

Don't house quality original prints in adhesive-backed board album pages (generally these have a quick-release acetate cover to protect each side of the album page).

Practically *all* of these products will at best cause base deterioration whilst at worst they will lead to irreversible image discolouration with specialist assistance being required to aid future intact removal.

Do use archival-quality photographic-specification album pages from a recognised archival products manufacturer or retailer and don't be afraid to seek external professional advice.

Don't use non-archival processing, developing or printing products for your quality original work.

Do contact your local archival photographic specialist who should be able to supply names of suitable products and/or companies offering such services.

Don't continue to store material in unsatisfactory environmental conditions.
Do consult your local photographic conservation expert for advice, or contact your closest authoritative body, specialist retailer or suitable conservation publications.

Don't continue to use ordinary storage products for your quality original material, look to the future, your images may be the history of tomorrow. **Do** take the necessary steps as outlined herein to ensure your images are preserved for the future.

The addresses are:

Conservation Resources International
8000H Forbes Place
Springfield
Va.22151
Tel: (703) 321 7730 Fax: (703) 321 0629

Archival Conservation Resources International
PO Box 2506
Ottawa Station D
Ontario, K1P 5W6

Conservation Resources (UK) Ltd
Unit 1
Pony Road
Horspath Industrial Estate
Cowley
Oxon OX4 2RD
Tel: (0865) 747755 Fax: (0865) 747035

Conservation Resources
241 Arthur Street
Fortitude Valley
Brisbane
Queensland 4006
Tel: (07) 528159

The task of sorting through a large library is quite enormous; it devours hours of time. However, if you value your collections it is well worth making as many regular inspections as time will permit. In recent years, much has been written about the conservation of documents generally, and yet items like glassine negative envelopes and slide-storage materials made of PVC and other destructive substances are still being sold over the counter in large quantities at highly inflated prices. Please complain loudly to your local stockists!

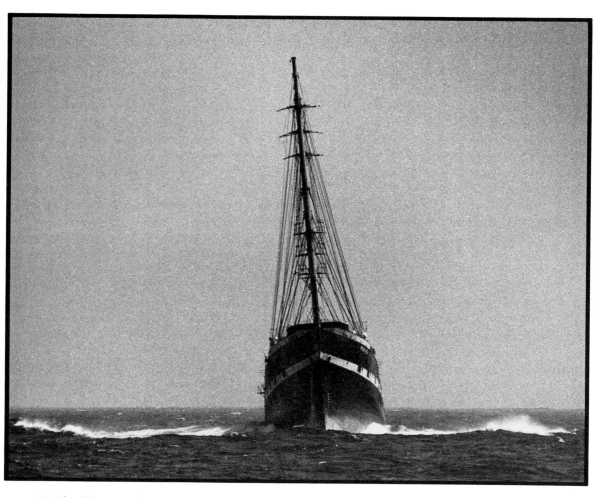

43. *The old nitrate clipper* Peking *labours in heavy swell a few hundred miles west of the Azores. 35 mm SLR, 300 mm lens.*

42. (PREVIOUS PAGE) *Night work, from a story on Trinity House pilots. The spotlight from the bridge wing provided just enough light for uprated Tri-x film.*

44. *Aari, the bosun on* Wijsmuller's *tug* Utrecht, *which was towing the* Peking *across the Atlantic.*

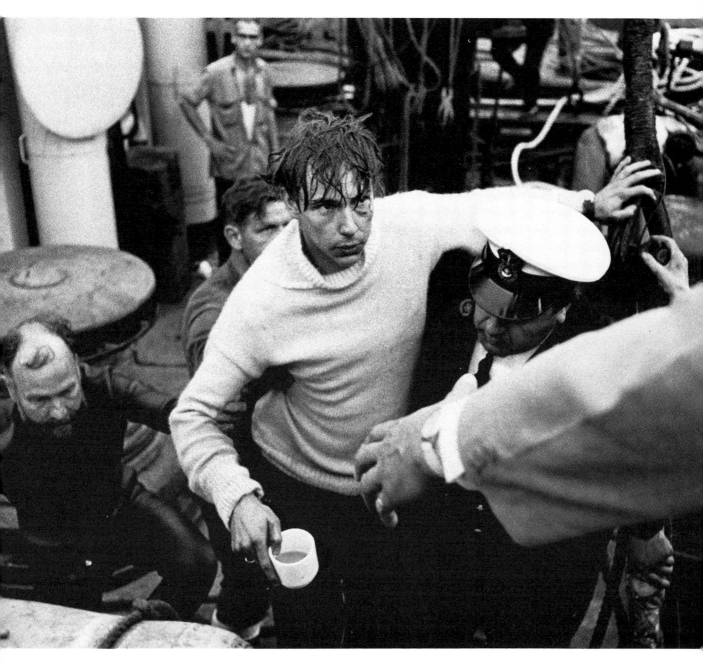

45. *Submariner Robert Croxon spent 10 hours on the seabed in the sunken submarine* Artemis *before rescue came. The photographer might have to wait – sometimes days – to get the right picture. (Courtesy of the Daily Telegraph.)*

46. (RIGHT) *A huge lifting wire runs amok on the football-pitch deck of the* Magnus X. *35 mm lens.*

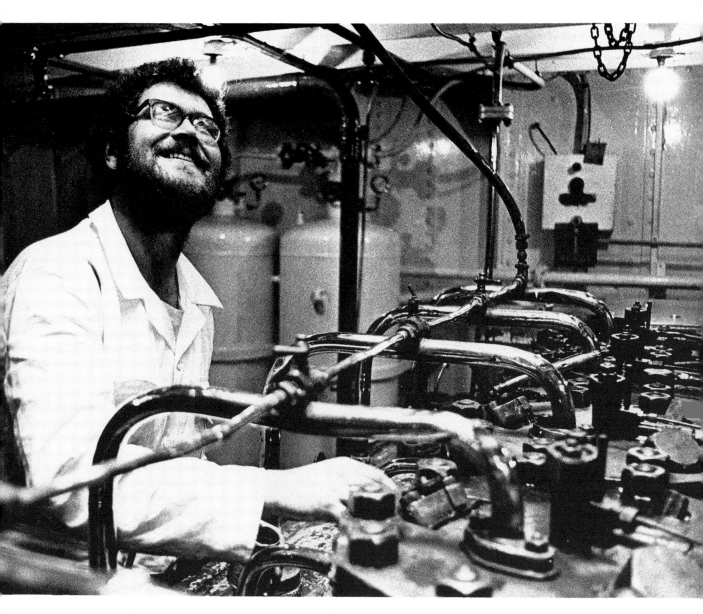

47. *An engineer's pride and joy. 105 mm lens, utilising available light through the hatch.*

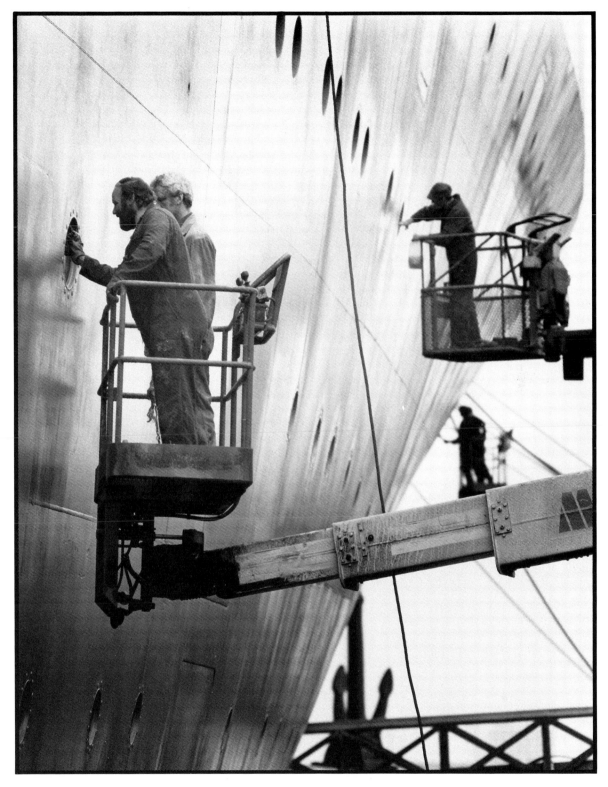

48. *Cleaning ship – a study in form using a long lens to achieve shallow depth of field.*

49. (OVERLEAF) *How good is a lens? This is from a 14 × 11 in print, and the frame was made on a battered Nikkor 35 mm f/2.8 lens. Age is no criterion; there are many good, old lenses available at reasonable cost.*

139

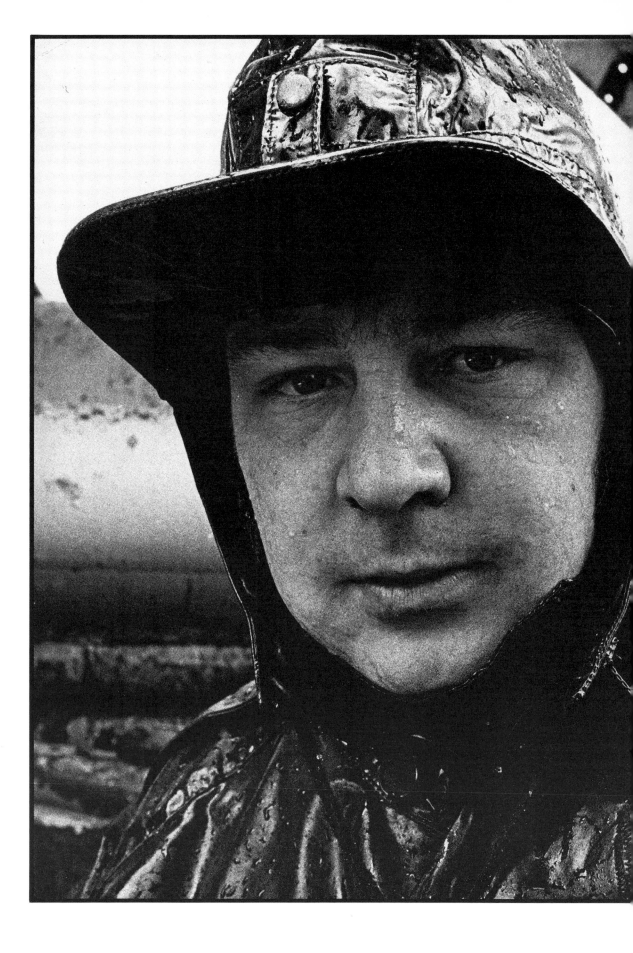

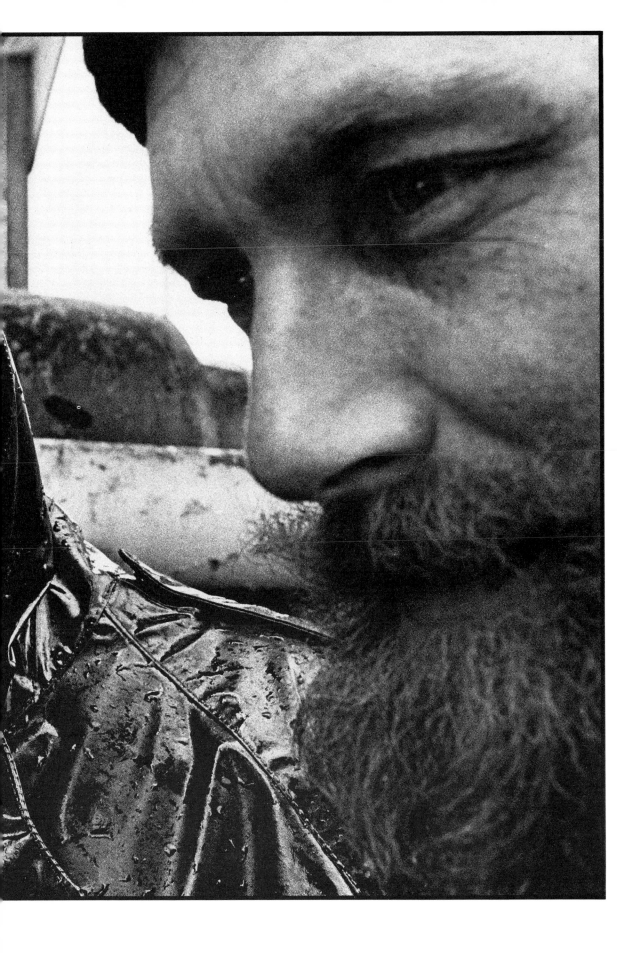

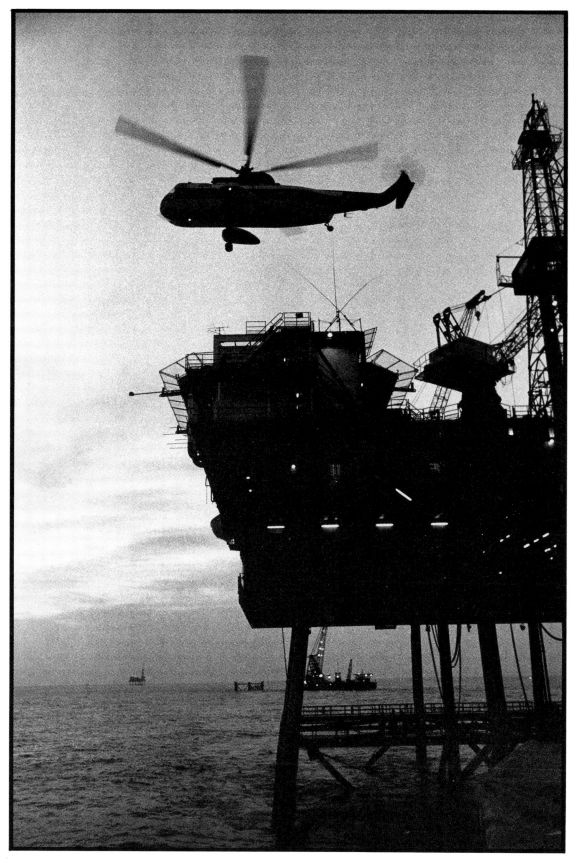

50. *Day's end in the North Sea, on a gas rig miles from home.*
It is rarely as calm as this.

9

PHOTOJOURNALISM

The feature or 'photo-story' is a collection of more than two pictures, with or without a supporting text, but usually accompanied by photo captions of reasonable length giving details of the names of various ships, yachts and people. The idea is that the photographs tell the story of what has happened as clearly as possible; the text, if it exists, fills in the background details; historical content, reasons for taking the picture, likely aftermath and so on.

The photographer working alone therefore needs to be able to form comprehensive captions for the work being produced. These words should be kept in a notebook at the time of shooting and should be enough for a caption writer to be able to produce the 'who, what, when, where and how' information which accompanies most photographs that are published.

It is not always possible for the freelancer to sell pictures without some form of supporting text and, increasingly, photographers write (sometimes extensively) on the subjects they photograph. In the case of feature work, supporting text may run to as much as 1500 words or more. If the text is reasonably competent and polished, the work will tend to sell a little easier than without.

Planning a feature or photo-story is not difficult, but it does take time to set up well and will take even longer to shoot and put together as a finished work. Deep-sea stories I have covered, for instance, have actually taken several weeks to photograph. In some cases this has involved coverage on a day-by-day basis, travelling to and from the location whenever the weather was suitable or there was some activity at the location which needed photographing. On other occasions, it has meant joining a strange ship in a strange port and setting sail on a voyage of indeterminate duration for an unknown destination. The latter have produced adventures of the purest kind, voyages which I often felt priviliged to be a part of because I was able to witness a little piece of maritime history and capture it on film. On other occasions I have become a live-aboard member of a ship's crew for weeks on end as it coasted from port to port, endeavouring to document the lives of professional seamen. There have been deep sea voyages on salvage tugs, supply ships, cargo ships and a host of vessels of

all shapes and sizes. It has at once been hard work, tedious, exciting, even exhilarating, but most of all, it has been fun.

Setting up feature stories involves, first of all, trying to establish what would be interesting for the reader, making an approach to the company concerned by letter or telephone and following this up with a visit to their headquarters. On some occasions, days of trying to set stories up have been wasted when the managing director has vetoed an idea at the last minute. Then you have to start all over again. When you first begin, it is not easy to convince those in charge that your intentions are honourable, or even that what you hope to produce will ever be published, since the freelancer should never take the name of a journal or a newspaper in vain.

A way around this problem is initially to approach the editor of a magazine familiar to you, discuss the ideas you have for a story and see what kind of support you get. If the editor agrees to give you a commission or pay part of your expenses, try to obtain a written letter accrediting you with the assignment. You are then in a position to make more confident advances to the company on whose ships you hope to sail. Any work of a similar nature that has been published, or simply a portfolio of prints, can also be shown to give an idea of what you hope to make new pictures of.

Story lines might simply evolve around the nature of certain work aboard ships at sea. It might be difficult, strenuous physical labour; it might be dangerous; it might be just plain boring, but all of these themes and many others are the basis around which photo-stories begin. To a certain extent they will develop as shooting progresses, because the photographer will come across things he knows nothing about and has never seen before. If a picture can be made out of both unusual and ordinary facets of life at sea, a story will begin to unfold. For instance, as each day passed, I would spend a few minutes before turning in at night, planning what I hoped to shoot the following day and figuring how those pictures might fit into the story I was trying to produce.

On long voyages, I always carry a sketchbook. I find that drawing out roughs of picture ideas helps to cement the ideas firmly in my mind's eye. Sometimes they work out in practice.

On one assignment I was aboard a giant salvage pontoon that had spent weeks in bad weather endeavouring to lift the wreck of a small coaster off the bed of an estuary, which was blocking the main shipping channel. I had been aboard for about 10 days and was beginning to worry that my self-appointed deadline was approaching at an alarming rate and nothing much had happened to warrant my being there, apart from the wonderful camaraderie of the crew.

The deck of this floating pontoon was the size of a tennis court. The huge wire hawsers used for anchoring the vessel and controlling its position over the wreck were first of all dragged off the winch drum and laid out on the pontoon deck. There were miles of the stuff, snaking up and down the length of the hull, just lying there with a dormant, greasy black wickedness. The tugs would take one end of the wire and tow it to the new anchorage where it would be attached to an anchor and dropped over the side.

I was enjoying the spring sunshine, seated outside the saloon with my typewriter, when an almighty rumble began at one end of the ship. From where I was sitting, I could see nothing, so I put down the typewriter and leapt down a couple of steps to peer around the midship's accommodation block. As I came off the bottom step, a rush of air and a cloud of rusty dust whistled by my ear. I knew instinctively what had happened and rushed to grab a camera from the steps. The dance was in full swing, a wire had snapped and was hurtling over the side of the pontoon, its tail swirling around the deck like a demented snake.

This, and many other stories like it, were frequently self-generated. Editors were often reluctant to make the ultimate commitment of assigning me for weeks on end to a project which they could never be sure would produce the goods. In a way, I much preferred to work like this, and still do. On my head be it if the story is a disaster. As time went by, I became attuned to selecting the kind of material I thought some editors would like and therefore did not have to try and sell the story until it was completed. There were other reasons for keeping quiet until after the event. These were usually because I knew the story was good enough to encourage competition from other photographers should word get about that facilities were available. A trip up the River Seine to Paris on one of the Royal Navy's 100-ft fast patrol boats was a case in point. On reaching the mouth of the river, our skipper had slowed the boat from 40 knots to a crawl while we stooged about and requested a river pilot. We had been told to expect a leisurely cruise up the river at a regulation 6 knots and that some of the French *peniches* might arrive before we did.

When the pilot, the epitome of a Breton fisherman, finally clambered aboard and made himself at home in the 'dugout', one of the first questions he asked the skipper was the maximum speed of our illustrious vessel. He never twitched a muscle when given the answer and simply said in broken English,

'Ve go. Allez maximum speeds ah Paree, oui? . . .'

The sun was setting as we hurtled under the giant suspension bridge at Tancarville and roared up the still waters of the Seine toward Rouen and

our first overnight stop. After Rouen, the river gradually narrowed, twisted and curved in wide sweeps under the limestone rocks and undulating hills of Normandy. Rushing up the river at full pelt in 100 tons of turbine-driven machinery was an exhilarating experience and one I am sure that pilot would never forget.

I was invited by the Navy's public relations department to go on that trip, but a voyage on a deep-sea tug towing the remains of an old clipper ship to New York took longer to set up. A small story in a national paper had reported the sale of an old training ship, the *Arethusa* to an American museum and said that she was to be towed to her new home. It seemed to me a unique opportunity to gather more material about the lives of professional seamen.

The *Arethusa* turned out to be an old nitrate clipper called the *Peking* which had featured in some famous film footage showing the perils of Cape Horn. She had been towed from the Medway to a dry dock in London where work was being carried out to make her seaworthy for the tow across the Atlantic.

It seemed to take weeks to get through to the right man, the late Captain 'Hap' Paulsen who once commanded the US Navy Coastguard training ship, *Eagle*. He knew all there was to know about square riggers and had been called out of retirement to take on the *Peking* project. I visited him several times during his stays in London and he finally told me I could go with the tug. There was much to do because apart from making a stills record of the voyage, the South Street Seaport Museum who had bought the ship, also wanted a film made.

Wijsmuller's, the Dutch owners of the tug *Utrecht* gave me a comfortable berth on board and after several weeks of preparation we set sail from Sheerness with the *Peking* stretched far astern on a huge wire. As voyages go, it was fairly uneventful apart from a little bad weather off the Azores, several engine breakdowns and one traumatic moment in the middle of the night when I ventured out on deck with the skipper to find the *Peking*'s bowsprit about ready to take away the tug's mast and radio aerials. We were lucky. It was a calm night.

The two crew embarked upon the *Peking* had a much more exciting voyage. The bad weather virtually demolished their sleeping quarters and there were times when, from where we were stood, it looked as if the old girl was about to stand on her bowsprit. They lost the fo'c'sle head davit and an old safe crashed through a bulkhead, demolishing the end of a bunk before plummeting through the 'tween decks to the bottom of the ship. For an anxious hour or so, no one could tell whether it had gone through the bottom of the ship or not.

146

It was a long voyage, almost three weeks before we picked up the loom of the Sandy Hook light. I had managed to shoot virtually all of the film for the movie as well as most of the stills stock. We arrived in New York to a clamour of tug sirens and waterjets and the first people to come aboard in the welcoming party were journalist friends from England, who just happened to be passing through New York! The *Peking* tow made an interesting but fairly sedate story and published well at home and abroad. I was glad to have been there.

Very few, if any, of these assignments or others like them could be called glamorous. They are not sufficiently important to ever make the pages of international news magazines, except perhaps occasionally as the odd single shot and caption. But to me, they do have some importance in forming part of the huge document of our national maritime heritage. And, if that sounds a little pompous, there is also the not-inconsiderable element of adventure, which I have to confess, keeps pulling me back time after time. It does not seem to matter whether it is a simple trip across the harbour, a run up the Solent in a pilot launch in bad weather, a North Sea ferry trip, a race to the Fastnet Rock or a high-speed ride through the klongs of Bangkok.

On another assignment, I had sailed on a coaster to Immingham to load coal for the Thames. The story was simple enough: the coasting trade and the men who still plied it. On the return voyage the skipper had received instructions to tow another of the company's ships south to the repair yard at Greenhithe. The vessel, a small tanker, had gone aground and damaged her rudder.

Once loaded, we proceeded to the mouth of the Humber and took over the tow from a local tug. As the night progressed, the weather worsened. By dawn there was half a gale running up the North Sea and the tow had broken three times. All next day, the skipper struggled to keep control as we proceeded slowly south. By the next night we were south of Great Yarmouth and in danger of grounding on the sand banks off Lowestoft. After standing lookout on the bridge for four hours, the weather began to moderate and I turned in for the night, glad to be in my warm bunk and lulled to sleep by the motion of the ship.

I woke to find the light of a torch piercing the cabin blackness. The skipper was yelling at me to do something, but I only got the bit about the second officer having tripped on the boat deck and smashed up his leg. The ship was lurching violently as I struggled up the bridge ladder. The skipper was alone, out on the wing looking anxiously aft at the lights of our crippled tow dancing well astern.

'The tow's gone again,' he yelled. 'Get on the wheel.'

The engine room telegraph clanged backward and forward.

'Hard a' starboard.'

Another clang of bells from the telegraph.

''Midships, port easy . . .'

And so it went on through the rest of the night and most of the next day. The second officer, it turned out, had broken his ankle and was laid up. The rest of the crew, including the first officer, were all aft, struggling to reconnect the tow. They would get it and make it secure and then it would ping apart again. The poor skipper was dead on his feet and had no one apart from the photographer to steer the ship. I grabbed the odd picture when I could, but my mind was elsewhere. Owing to a broken ankle I felt as though I had been transported back in time to my merchant navy days – a way of life I thought I had left behind. Ironically, perhaps it was during those few hours at the wheel of a struggling coaster I realised that no matter how much I loved my job as an observer, the sea would always be there. Whether I needed it or not, it was a part of my life. I could no more leave it than it could leave me.

Index

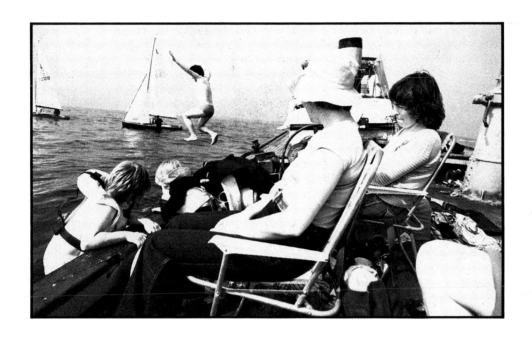

Grateful thanks to

Ian Dickens, Olympus Optical UK
Jane Harvey, Canon UK
R. Hiesinger, Novoflex, Germany
Tony & Sue Carney
John Foulkes
Adam Eastland
Masao Yamaki, Sigma Corporation, Tokyo
The Associated Press Ltd, London
Andy Rose, logistics

Cameras used
Olympus OM1n, OM3, OM4Ti
Hasselblad
Canon T90
Leica M4-P, R3